SECRET DUNFERMLINE

Gregor Stewart

AMBERLEY

First published 2018

Amberley Publishing
The Hill, Stroud
Gloucestershire, GL5 4EP

www.amberley-books.com

Copyright © Gregor Stewart, 2018

The right of Gregor Stewart to be identified as the
Author of this work has been asserted in accordance
with the Copyrights, Designs and Patents Act 1988.

ISBN 978 1 4456 6138 4 (print)
ISBN 978 1 4456 6139 1 (ebook)

British Library Cataloguing in Publication Data.
A catalogue record for this book is available from the
British Library.

Origination by Amberley Publishing.
Printed in Great Britain.

Contents

Introduction

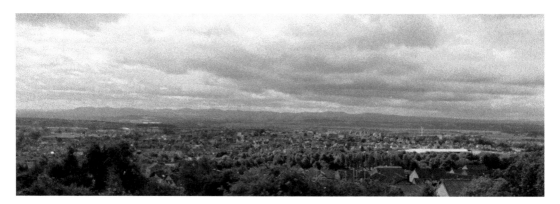

General view overlooking Dunfermline from Townhill.

The town of Dunfermline in Fife sits on an elevated position a few miles from the banks of the Firth of Forth. A former royal capital of Scotland, the town came to prominence in 1070 through the marriage of Malcolm III to Queen Margaret. This union brought wealth and prosperity to the town, and resulted in it becoming both a major political and religious centre in Scotland.

Yet as was so often the case, difficult times lay ahead for the town. The religious reformation brought destruction and the loss of its religious status. The Union of the Crowns ended the town's connection to the monarchy and a disastrous fire almost brought the town to an end. However, the resilience of the townsfolk saw Dunfermline survive, and before long it was once again rising in status to become a world leader in the production of linen. This industry would not survive after the world wars, but a Royal Navy base that had been established to counter the German threat filled any gaps in employment, and brought many people to live in the local area.

The historical importance of events that happened within Dunfermline's Royal Palace and Abbey have secured its place as an important town in Scotland, with famous sons and daughters who have not just been influential in shaping both Scotland and the United Kingdom, but have been influential worldwide.

The Origins of Dunfermline

There is evidence of human occupation around modern-day Dunfermline that dates back to the Pictish times, or even earlier. Although little is known about the Picts due to the lack of written records, they are believed to have lived as individual kingdoms, each with their own society and leaders, who would come together in the event of a common goal, most commonly to expel invaders to their lands.

In these primitive times locations for their strongholds were carefully chosen with a number of requirements including height to allow attackers to be seen well in advance, and a fine balance between inaccessibility to deter enemy forces,

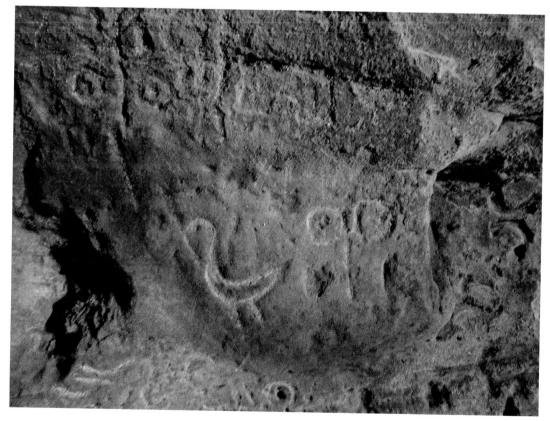

Pictish cave carvings in Fife.

This page and opposite: Pictish cave carvings in Fife.

without being so inaccessible it was not possible to get the raw construction materials such as stone and wood to the site. Rivers also played a significant role as they offered a natural defence and supply route for transporting goods. Both the weakest point defensively and the strongest point for landing transported equipment was the lowest, narrowest crossing point, and so it was not uncommon for high points around these areas to be chosen for building forts.

With the Roman fortress at Cramond near modern Edinburgh, and the Antonine Wall stretching the width of the country across the central lowlands, defence of the River Forth was essential. The exact location of the Pictish fort is not known, although it is believed it would have stood around the area of Pittencrieff Park in Dunfermline. What is curious about the fort is despite the location being chosen partly for defensive purposes, it does not appear to have been attacked during the period of Roman occupation (around AD 84 to AD 440), despite it being known that the Roman legions both passed through Fife in the advance north, and had several camps in Fife. One such camp is likely to have had some significance due to its position sat to the east of Dunfermline, close to Calais Muir Woods (derived from the Gaelic word 'coille' meaning forest or woodland rather than any connection to the French city and port): Pratehouse. It is thought this was the location of a Roman praetorium, which was a Roman general's tent within an encampment. Despite being a tent, these were often

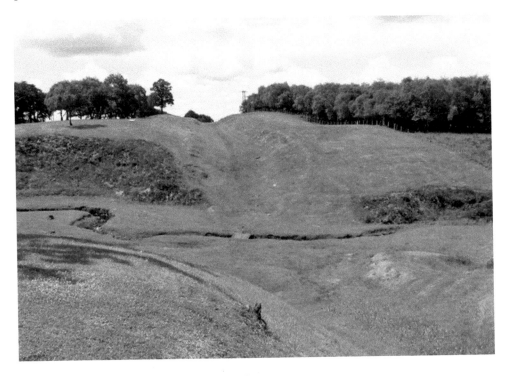

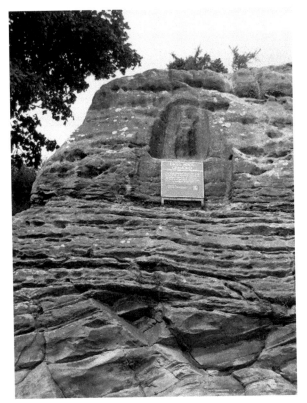

Above: The Antonine Wall viewed from a Roman fort at Rough Castle. (© Lairich Rig (cc-by-sa 2.0))

Left: Eagle Rock near Cramond, said to be a Roman carving attached to the rock during the period of Roman occupation. (© Richard Webb (cc-by-sa 2.0))

The Pitcorthie standing stone. Although now positioned in a housing estate, the stone originally stood on a hill and is believed to date back to between 2500 and 1500 BC. (© Paul McIlroy (cc-by-sa 2.0))

significant structures within their own right, and would have been where the generals held all of their important and strategic meetings as they sought to take control of the country. Because of this, the camp would have been protected by an elite division of the Roman army, known as the Praetorian Guard, and the hill on which the camp stood was known as the Praetor Hill. It is believed that this was the origin of the name 'Pratehouse', with it either deriving from 'Praetor Hill', or more likely referring to the praetorium as the 'Praetorhouse' ('residence of the Roman chief'). The area of Pratehouse was largely quarried for limestone in the nineteenth century to fuel the limekilns, the remains of which can still be seen in the woods, but by the 1850s Preatorhill Quarry was falling into disuse and was later partially filled in.

Another camp was situated at Chapel Farm, on the outskirts of Lochore Meadows Country Park, but of more significance to Dunfermline, a large encampment stood at Carnock, around 4 miles from Dunfermline town centre. It is recorded that during the first century, the Roman army occupied much of the south banks of the River Forth and their boats were sent to explore the north banks looking for natural harbours and signs of what native forces they may face.

Calais Muir Woods. (© Robert Struthers (cc-by-sa 2.0))

One attempt to land at Torrybury was defeated when Caledonian warriors ran into the shallow waters to force the invading forces back. In the year AD 83, despite serious opposition, the Roman General Gnaeus Julius Agricola advanced his forces north and into Fife. Although much of the evidence has been lost, it is believed that the Roman forces set up not one, but two camps at Carnock. The camps were very close and on the same ridge, and so it is surmised that one camp was for the infantry and one for the cavalry. Very close to the locations of these camps, on the outskirts of Oakley is Carneil Hill, notable for its steep sides and flat top. It is believed this may have been the site of a Caledonian fort, and the Roman forts were established while they laid siege to it. Canmore, the National Record of the Historic Environment, record this as a supposed site of a battle with the Romans, and discoveries made there seem to support this suggestion, or at least support the Roman occupation. In 1774, a small mound of earth and stones was excavated to determine whether this was a burial mound. A number of urns were found inside containing Roman coins and other artefacts dating to the first century. Additional urns were found a short while later, also containing

coins, which had no decipherable inscriptions and so it could not be verified they dated back to the Roman era, although it is thought likely they did. Around 1803, a Roman urn was found by a farm labourer named Mr Davidson, which contained the charred bones of two children.

DID YOU KNOW?
Very little is really known about the Picts. Known as the 'Painted People' by the Romans, due to the bright coloured pigments they would cover themselves in, the Picts kept few written records. What we know about them is mostly from the writings of those who came across them. The Picts did leave a number of carvings and drawings, which seemed to be a main way to communicate, yet without knowing what the symbols mean, these are difficult to decipher.

Unfortunately, no trace remains of these important sites due to farming over the centuries, and the potential connection of the site as the first camps north of the River Forth occupied by the Roman General Argicola in his campaign to northern Scotland has been lost. In the year AD 77, Argicola was appointed the Governor of Britain, and his march forward from the security of the south banks of the River Forth marked the start of a period when he took control of significant parts of Scotland. In AD 83, the general's forces were met the Caledonian forces led by Calgacus at the Battle of Mons Graupius. The location of the battle is not recorded, and is fiercely debated, yet from the descriptions given of the battle site of there being nothing beyond but sea and rocks, it most likely took place on the Moray coast. Despite being massively outnumbered, the disciplined Roman army was victorious, and it seems they believed that they had reached the top of Scotland as the Romans declared that they had now taken control of the whole of Britain. Argicola was called back to Rome the following year, and with the threat from the Caledonians in the north once again growing, the Romans retreated to the security south of the Forth once again, having never managed to take Britain. It is unfortunate that nothing could have been preserved of the hill forts, although a small reminder remains with the farms to the east and west of Carnock being named East Camps Farm and West Camps Farm.

It is a similar situation at Pratehouse, where there was not one, but three quarries in that immediate area, making it difficult to imagine the extent of archaeological evidence and information of the Roman occupation that was lost. Quarrying did not, however, only destroy evidence, it was also responsible for

some discoveries. In the late nineteenth century, excavation work to the north of Calais Muir Woods uncovered a Bronze Age burial cairn, indicating even earlier settlements around current Dunfermline than those from the Roman period. Within the cairn, around ten urns were found containing burned bones and charcoal, indicating they were remains of cremations. Other broken fragments of urns and burnt bones were also found, which could be a sign that the cairn was of some importance, possibly a burial place for generations of the same family. The answers will never be found, as the cairn was almost completely destroyed by tree planting over the following years.

With so much happening in the local area, we should once again look at why the defensive fort at Dunfermline appears to have avoided attack, and the reason may lie in a discovery made in 2014, when a young metal detectorist discovered

Part of the old limekiln on the east edge of Calais Muir Woods. (© Robert Struthers (cc-by-sa 2.0))

Figures of Roman soldiers guarding the entrance to the site where Castlecary Roman fort, part of the Antonine Wall, once stood. (© Euan Nelson (cc-by-sa 2.0))

a hoard of silver pieces dating back to the Roman period. Known as hacksilver, these had originally been larger silver items that had been hacked into smaller pieces to be used as payment, and it is thought their discovery shows that the Romans used the silver to offer bribes to the Picts to try and gain safe passage through the area, minimising the number of battles they faced.

DID YOU KNOW?
While some believe that the name Carnock comes from the cairns on the hill ('knock' means hill, and so Cairn Knock became shortened to Carnock), it may actually be derived from the Roman camps. The word 'caer' means a camp or fort, and so Caer Knock would mean 'a fort or camp on the hill', later shortened to Carnock.

The Birth of Dunfermline

It was not until the eleventh century that Dunfermline started to rise in importance as a town due to it being chosen as the location for the marriage of Malcom III and Queen Margaret.

Malcolm III is perhaps better known in Scottish history through fiction rather than fact. His father, David I, faced a challenge following his accession to the crown from his own cousin, Mac Bethad mac Findlàech, a powerful lord in the north of Scotland, resulting in King David taking an army north to assert his rule as the king. The mission was doomed, and on 15 August 1040, during a battle near Elgin, King David was slain by his cousin. Malcolm was only nine years old at the time, yet as the natural successor to the throne after his father death, it was recognised that Mac Bethad posed a considerable threat to the his safety and so he was transported to England and put under the protection of his mother's cousin, Earl Siward Biornsson of Northumbria. In the absence of Malcolm, Mac Bethad claimed the throne and was crowned King of Alba.

In 1053, aided by King Edward the Confessor of England, Malcom and Siward invaded Scotland. As he marched north, he gained considerable support from the lowland nobles including the Thane of Fife, who recognised him as their true king. On 15 August (coincidentally the same date his father had been killed) 1057, Malcolm's forces met those of Mac Bethad at the Battle of Lumphanan in Aberdeenshire. Malcolm was victorious, with Mac Bethad being slain on the battlefield. That was not to be the end of his campaign however, as Mac Bethad's stepson laid claim to the throne through his mother's connections. Rather cruelly known as Lulach mac Gilla Comgain, meaning 'Lulach the Simple', or 'the Fool', it seems he had been overlooked as a potential monarch in these difficult and brutal times due to his reputation as having low intelligence; however, apparently he had been underestimated and he was crowned king in August 1057. His reign was short though, and he was assassinated in March 1058, many believe by, or on the instructions of, Malcolm, who was crowned king at Scone on 17 March 1058.

DID YOU KNOW?
Canmore in the anglicised version of Malcolm III's name means 'big head'. This rather uncomplimentary translation for the title of a monarch was later said to mean either 'Great Head' to represent intelligence, or 'Great Chief' to represent his role as the head ruler of the country and his battle prowess.

These very real characters in Scottish history would be immortalised in the play *MacBeth* written by English poet and playwright William Shakespeare around the start of the seventeenth century. The plays main characters are:

Duncan (King Duncan of Scotland)
Malcolm (King's Duncan's son)
MacBeth (the abbreviated version of Mac Bethad mac Findlàech and the name he was better known as)
MacDuff (the Thane of Fife who joined Malcom's forces)
Siward (Earl Siward Biornsson of Northumbria)

It could be considered unfortunate that by being best known through this fictional play, many assume the characters to also be fictional and do not recognise their place in history. King Lulach, MacBeth's stepson, was the last king of the House of Alpin, a dynasty that had started in the year 843 when Kenneth I became King of Alba, uniting the kingdoms of the Picts and the Scots. Malcom III Canmore (also known as Máel Coluim mac Donnchada) was the first king of the House of Dunkeld, a dynasty that would rule over Scotland for the next 250 years. Malcolm III was also the first King of Scotland, making King Lulach the last King of Alba.

Malcom III had three children with his first wife, Ingibjörg, the daughter of Thorfinn Sigurdsson, the Earl of Orkney. Following the death of Ingibjörg, he married his second wife, Margaret, in Dunfermline in 1070. Margaret was the great-niece of King Edward the Confessor of England, who had assisted Malcolm in retaking the Scottish crown. England had, however, been thrown into turmoil following the death of King Edward and his successor, King Harold, both in 1066, and so Margaret had been sent to the continent for safety, along with her mother and brother. However, a storm blew their boat off course and it landed in Scotland, where King Malcolm put them under his protection. It is highly likely he already knew them from his own time in England, and this could be seen as repaying the generosity shown to him by King Edward.

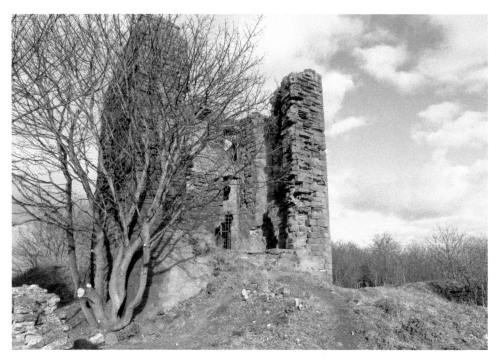

MacDuff's Castle in Fife.

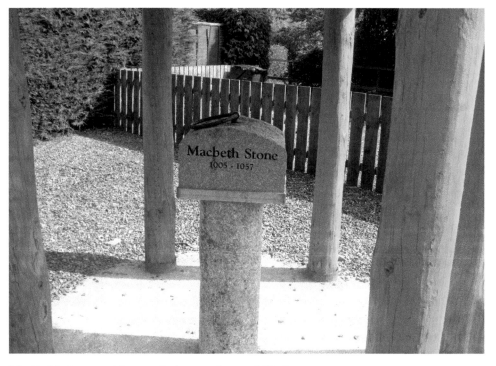

MacBeth's Stone, said to mark the spot he was killed.

King Malcolm had earlier had a tower built in Dunfermline, believed to be on the site of the earlier Pictish fort, which is turn cemented the earlier Gaelic name given to the town of 'Dun Fearam Linn', which means 'the fort in the bend of the stream or river'. It is perhaps difficult for to fully appreciate the defences this location offered when looking at the extensively altered landscape today. To give an example of how it once was, the area is described as follows in John Fourdun's Chronicle of the Scottish Nation:

> For that place was of itself most strongly fortified by nature, being begirt by very thick woods, and protected by steep crags. In the midst thereof was a fair plain, likewise protected by crags and streams; so that one might think that was the spot whereof it was said: 'Scarce man or beast may tread its pathless wilds'.

Although the translated version of Fordun's writings used for the research of this book were published in 1872, John of Fordun, who is widely considered to have been the first chronicler to write a continuous history of Scotland, lived from around 1330 to 1384, with his Chronicles being published around 1360, and so this description would have accurately described the land as it was at that time.

The steep slope leading to the site of Canmore's Tower.

MALCOLM CANMORE'S TOWER

THERE IS NO HISTORICAL MENTION OF THE TOWER OF DUNFERMLINE UNTIL ABOUT A.D. 1070, WHEN MALCOLM CANMORE AND HIS QUEEN-PRINCESS MARGARET-CELEBRATED THEIR WEDDING.

DUNFERMLINE TAKES ITS NAME FROM THREE CELTIC WORDS - DUN (A HILL OR FORT) FEARAM (BENT OR CROOKED) LIN, LYNE OR LINE (A POOL OR RUNNING WATER).

THE TOWER WAS ADOPTED AT AN EARLY DATE FOR THE BURGH ARMS OF DUNFERMLINE, AND OLD WAX SEALS SHOW IT TO HAVE BEEN A BUILDING OF TWO STOREYS WITH ATTIC, ABOUT 52 FEET FROM EAST TO WEST, AND 48 FEET FROM NORTH TO SOUTH. IT CONTAINED ABOUT TWENTY SMALL APARTMENTS.

BEFORE THE ROADWAY TO THE SOUTH, WHICH WAS THE WESTERN ACCESS TO THE TOWN, WAS FORMED, THE TOWER, PERCHED ON ITS PENINSULAR ROCK, WAS AN ALMOST IMPREGNABLE FORTRESS. THIS FACT NO DOUBT LED TO DUNFERMLINE'S MOTTO "ESTO RUPES INACCESSA".

HISTORIANS ARE OF OPINION THAT THE TOWER WAS WHERE

"THE KING SITS IN DUMFERLING TOON DRYNKING THE BLUID-RED WYNE".

The memorial plaque at the entrance to Canmore's Tower.

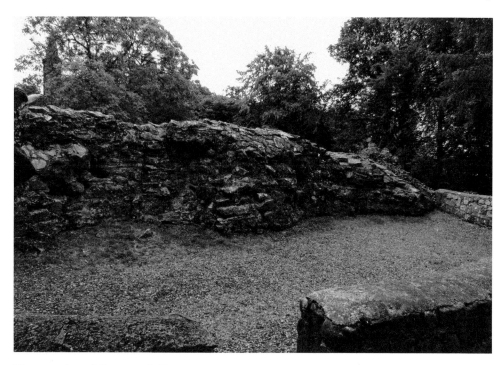

The remains of Canmore's Tower.

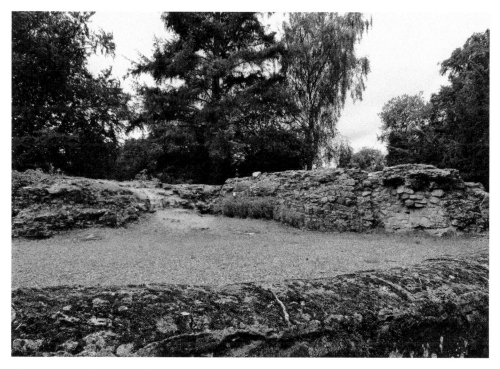

The remains of Canmore's Tower.

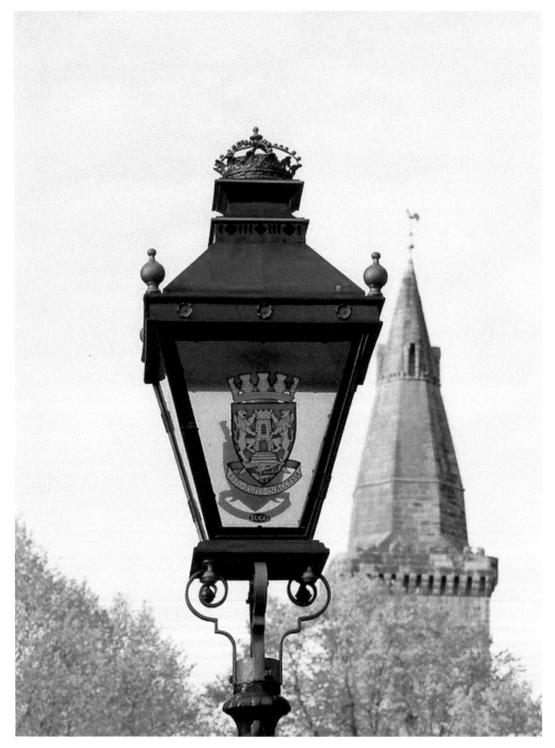

This lamp post situated outside the City Chambers depicts the Dunfermline Burgh Arms.
(© Paul McIlroy (cc-by-sa 2.0))

Little is really known about Canmore's Tower, as it became known. Even the description given above of the local geography does not actually mention the tower itself. It is believed that, although it was described as a tower, this was a fully defended castle, which marked Malcolm III moving his court to Dunfermline from Forteviot in Perth and Kinross around 1065, with the tower being believed to have been built sometime between 1056 and 1070. Much of the details known about the tower are taken from early drawings and etchings, and it is perhaps fortunate that the tower was adopted in the Dunfermline Burgh Arms, which show the building with a Loin Rampart on each side supporting the walls. A charter found at nearby Pitfirrane is believed to date back to around 1500 and is thought to be the earliest seal surviving that, although broken and decaying, shows a crude impression of Canmore's Tower. Believed to have stood three storeys high, accessed via steps with the entrance protected either by metal gates or a drawbridge, archaeological explorations indicate that the tower in fact had a relatively small footprint for a royal residence, and it is estimated to have had in the region of just twenty rooms. Despite this, having been built for comfort, it was a favoured residence for King Malcolm and Queen Margaret and the birthplace of most, if not all, of their eight children.

DID YOU KNOW?
The little-known settlement of Dunfermline was chosen as the location for the marriage of Malcolm III Canmore and Queen Margaret in favour of the larger, more prestigious locations such as Edinburgh, Glasgow or St Andrews, as it is believed the boat carrying Margaret, along with her mother and brother, was washed ashore at a bay not far from Dunfermline.

Not satisfied with providing Margaret and her relatives with a safe, secure residence, King Malcolm began making military advances into England in an attempt to force back the Norman forces who had taken England, and to restore Margaret's brother, Edgar the Atheling, as the rightful heir to the English throne. This was also in the king's best interests, as it would allow the expansion of the Kingdom of Scotland, and place a friend and relative as the King of England. Unfortunately, his attempts were unsuccessful and his forces were repeatedly forced back by the army of William I (better known as William the Conqueror).

In 1072, King William advanced north and in the village of Abernethy, around 25 miles north of Dunfermline, King Malcolm was forced to sign a document swearing allegiance to King William in what became known as the Treaty of Abernethy. In return for signing the treaty, Malcolm was given estates in Cumbria, but was also required to hand over his eldest son, Duncan, to be held as a hostage of King William to ensure the promise made by Malcolm to cease attacks on England was kept. This treaty is considered to be of high importance in Scottish history, as it was the basis for several future claims that the English king was overlord to any Scottish monarch.

In 1087, William I of England died and he was succeeded by his son, William II. At the same time, Duncan was released and sent home to Scotland. With his son no longer being held hostage and there being a dispute over the right to the English crown between King William and his brother, Robert, King Malcolm once again commence his attacks on England. He made some headway into Northumbria in 1091, but was unexpectedly met by a massive English force, commanded by William II himself, and forced back. In retaliation, King William sent an army to attack and take King Malcolm's estates in Cumbria. Construction commencing on Carlisle Castle was seen as King William stating his intention to defend the English rule to the North of England, prompting King Malcolm to once again invade, this time with fatal consequences. In November 1093, King Malcom had advanced as far as Alnwick, where his army made camp in the high ground around the castle. A stealth attack by English soldiers mustered from nearby Bamburgh Castle, led by Robert de Mowbray, Earl of Northumbria, caught the Scots completely by surprise and in what became known as the Battle of Alnwick, King Malcolm was slain. His eldest son, Edward, was mortally wounded and with no leader, the Scots army fled from the battle.

Little remains of Canmore's Tower today, having been destroyed by Edward I in 1304. All that the can be seen is an L-shaped lower portion. This measures 13 metres north to south and 4 metres east to west, and although this is likely to only be part of the building, it confirms the small footprint. The site has been extensively excavated since Victorian times, and large sections have been stripped right down as far as the bedrock, meaning there is no evidence remaining of the full extent of the building. The site is, however, considered to be of historical significance and is listed as a Scheduled Monument by Historic Environment Scotland due to its importance as the residence of King Malcolm and Queen Margaret.

DID YOU KNOW?

King Malcolm's residence at Dunfermline is mentioned in a children's maritime ballad, named Sir Patrick Spens, first published in 1765. The ballad tells of the king's quest to find a sailor to command a ship on a royal errand. Sir Patrick Spens is appointed and commanded to set sail immediately, despite it being winter, and versions vary between his ship sinking on the way to, or back from, Norway in a great storm. The ballad starts:

> The king sits in Dunfermline toune
> drinking the blude reid wine,
> 'O whar can I get skeely skipper,
> To sail this ship o' mine?'

A stone cross known as Malcolm's Cross stands in the woodland on a hilltop close to Alnwick. (© David Clark (cc-by-sa 2.0))

Queen Margaret and Dunfermline

While King Malcolm's connection to Dunfermline was significant, it was his wife, Queen Margaret, who would have a more dramatic impact on shaping the future of the town.

Queen Margaret was a devout Roman Catholic yet most Scots still followed the old Celtic religions, and so she set about making changes that would help shape Scotland's transformation into a Catholic country. Dunfermline already had a church, which had been established by the Culdee monks around AD 800. Although Christian, the Culdees were seen as Celtic Christian and differed from the traditions of the Catholic faith, particularly in the dedication of their churches to the Holy Trinity rather than to the Virgin Mary or one of the saints. The Culdees were also permitted to enter into marriage, although once they were took up their role in the church, they were required to abstain from their wives. With the position within the church generally being passed from father to son, this meant most Culdees already had children before succeeding their father in the church, allowing the hereditary line to continue.

King Malcolm and Margaret were in fact married by Fothad, the Culdee Bishop of St Andrews, yet she had a desire to bring the Catholic faith she was used to into the Scottish churches. Shortly after their wedding, Queen Margaret put into place plans to create a priory in the town, and it is generally believed that the small church in which she had married the king was the chosen site, with the church being altered and extended to house Benedictine monks she had brought to Dunfermline from Canterbury. In addition to the changes Margaret brought to the Scottish religion, King Malcolm also made other changes to try to make Margaret feel more comfortable in her new home, including changing the language of his court from Gaelic to Saxon. When Margaret was told of the death of Malcolm, she died just a few days later and was laid to rest in Dunfermline Priory. Malcolm had initially been buried at Tynemouth Priory, but in 1115 his body was exhumed and returned to Scotland, where he was reburied next to Margaret in Dunfermline.

The importance of the priory was not lost to the children of Malcolm and Margaret, who would go on to become kings themselves. In 1126, Alexander I, their fifth son, had the towers of the priory heightened, and the west gable with

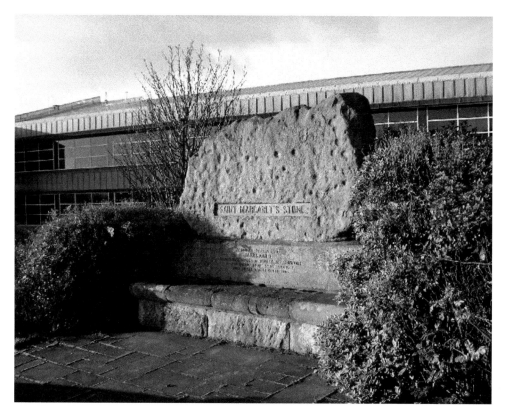

According to legend, while travelling to Dunfermline with King Malcolm in 1069 Margaret rested on this stone. It has since been relocated several times. (© Paul McIlroy (cc-by-sa 2.0))

The remains of the Church of St Mary's on the Rock, the Culdee church in St Andrews.

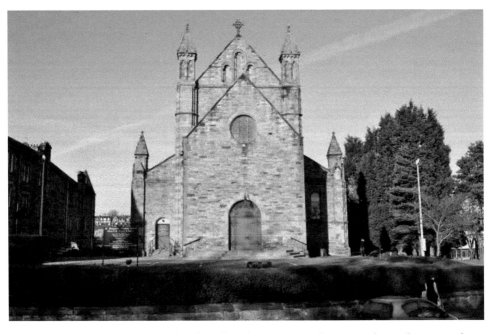

St Margaret's Memorial Church. This church was opened in 1896. (© Robert Struthers (cc-by-sa 2.0))

an impressive doorway and window were added, and 1150, David I, their sixth son, raised the status of the Church of the Holy Trinity to Dunfermline Abbey and work began to substantially extend the building. In 1250, a monk's choir and shrine to Margaret were added, with the remains of both Margaret and Malcolm being moved to the new shrine. The following year, Margaret was canonised by Pope Innocent, becoming St Margaret.

In 1303, during the Scottish Wars of Independence Edward I of England occupied Dunfermline and held his royal court in the Dunfermline Abbey. When he left, he had his forces destroy most of the buildings, yet what was noticeable was that while all of the domestic buildings were razed to the ground, the abbey church was left untouched. Even King Edward himself, known as 'The Hammer of the Scots', did not seem to want to cause any damage to the building, and it is believed this is out of respect to Margaret due to her strong connections with the Benedictine Order of Canterbury and with Rome. Alternative versions state that Edward did have the church damaged, and he stripped lead from the roof of the building to make ammunition for his assault on Stirling. It is possible that this version was given due to the general hatred of King Edward. Rebuilding

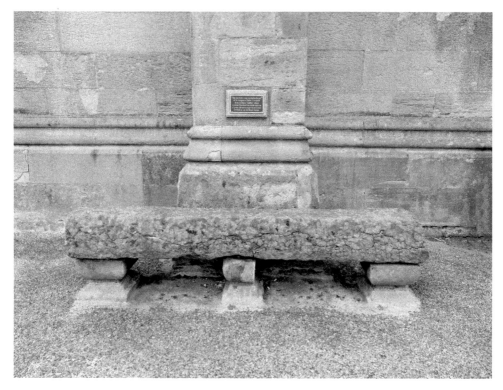

A seat outside Dunfermline Abbey Church, believed to have been made from a piece of the original shrine to Queen Margaret.

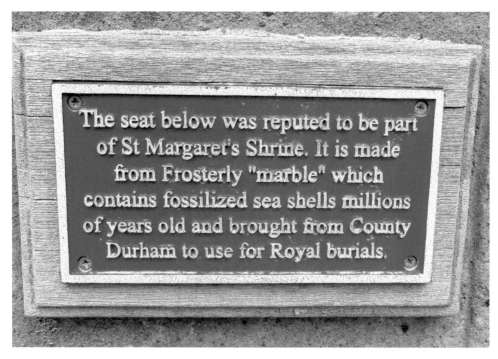

Memorial plaque giving a description of the seat.

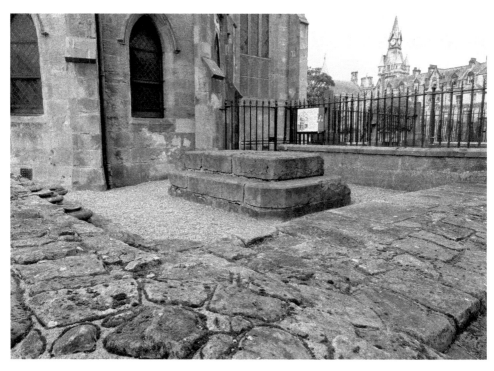

St Margaret's Shrine at the gable end of the abbey.

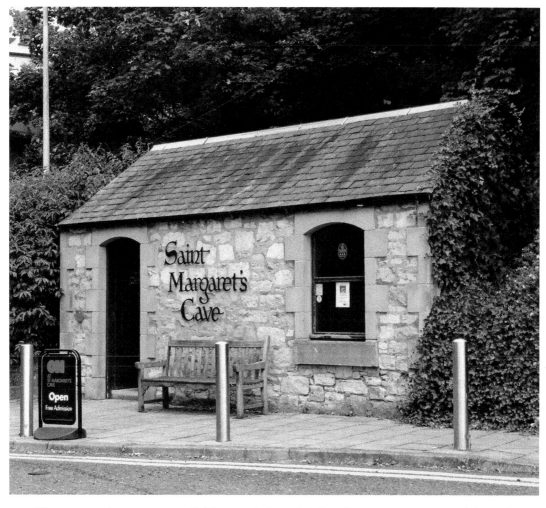

The unassuming entrance to St Margaret's Cave. It is in a deep cave now accessed through this small building, where St Margaret would go for private prayer.

work of the abbey started almost immediately and, after being crowned King of Scotland in 1306, King Robert the Bruce ensured that considerable aid was gifted towards the rebuilding. In March 1323, Queen Elizabeth, King Robert's wife, gave birth to their son, David, in Dunfermline Palace, and in doing so secured her husband's legacy with an heir.

From 1328, having secured Scottish independence, King Robert the Bruce spent a great deal of time in Dunfermline. He was suffering from ill health, and staying at Dunfermline allowed him to travel to nearby Scotlandwell to take the healing waters in an attempt to recover. On 7 June 1329, the king died at Dunfermline, and just six days later the Pope, unaware of his passing, authorised Robert the Bruce, and all of his successors, to be crowned as kings of Scotland, giving

official recognition to Scotland as an independent kingdom. He was buried at Dunfermline Abbey, but at his request his heart was first removed to be taken to the Holy Land. It only make it as far as Spain before being brought back to Scotland and being buried at Melrose Abbey.

DID YOU KNOW?
In addition to establishing the priory in Dunfermline, Margaret also had other work carried out on her behalf. She had a chapel built in Edinburgh Castle, now named St Margaret's Chapel, and had the monastery in Iona rebuilt. In order to aid the pilgrims travelling to worship at the major religious centres of St Andrews and Dunfermline, she also had a free ferry provided to transport pilgrims across the Firth of Forth.

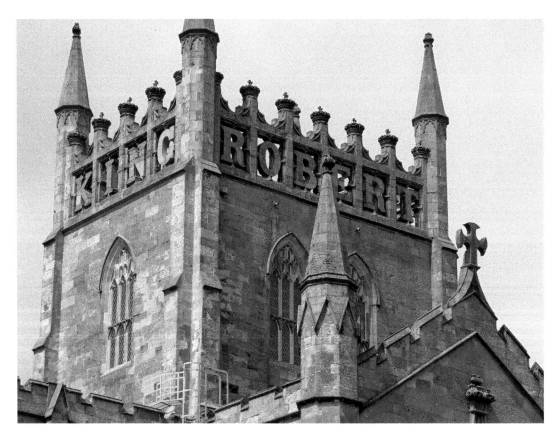

The top of the spire of Dunfermline Abbey Church commemorating King Robert the Bruce.

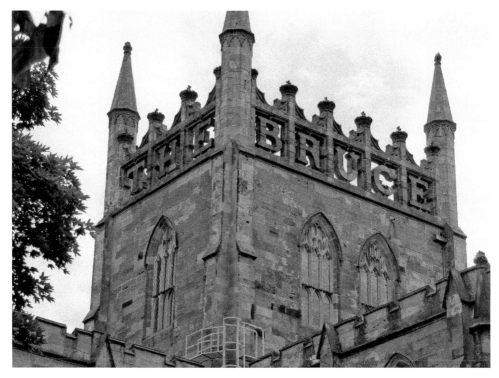

The top of the spire of Dunfermline Abbey Church commemorating King Robert the Bruce.

The Well House at Scotlandwell protects the healing waters of the well. (© G. Laird (cc-by-sa 2.0))

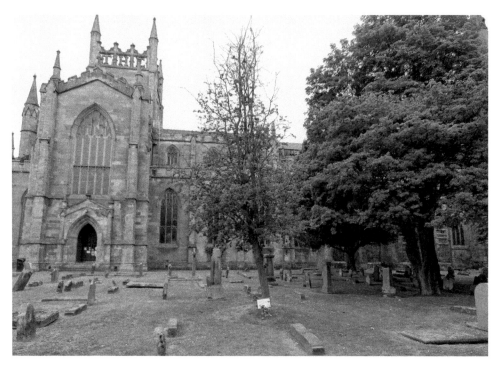

According to legend, when William Wallace was hiding from the English forces he visited Dunfermline with his mother and worshiped at St Margaret's Shrine. His mother died shortly after, and was buried in an unmarked grave. A hawthorn tree marks where she was buried.

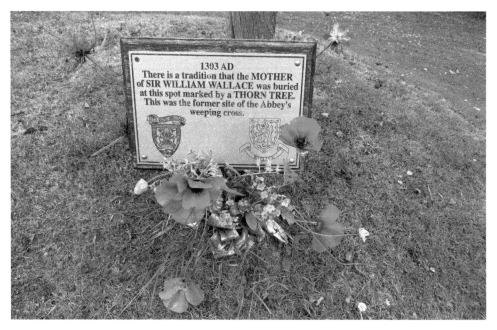

The memorial plaque and flowers left by visitors at the grave of William Wallace's mother.

The Protestant Reformation

Dunfermline had grown and prospered largely thanks to its status as a religious centre in Scotland. Unfortunately, it was also to be this status that would lead to its downfall. In order to appreciate what happened in Dunfermline, the state of the country must be put into context.

By the sixteenth century there were the first ripples of religious unrest in the country. While Scotland remained fiercely Catholic, other countries were starting to turn to the Protestant faith, and preachers who would come to be known as the fathers of the European Reformation travelled across the continent preaching the new ways. A young man named Patrick Hamilton had listened to the words of one of these preachers, Martin Luther, and when he returned to Scotland and took up a place at St Andrews University, he was full of enthusiasm to tell all about what he had learned during his travels. It is not really known whether his decision to promote the Protestant faith in St Andrews, the home of the Catholic Church in Scotland, was a foolhardy mistake or a deliberate intention to make a stand. Whichever it was, it certainly got the attention of Dr James Beaton, Archbishop of St Andrews, and instructions were issued to arrest Hamilton on the charge of hersey. The young student fled back to the continent, but soon returned to St Andrews and continued preaching between studies. Initially, he was left to do so, but this was part of the archbishop's plan, and once Hamilton felt more secure, he was invited to meet with the Archbishop at St Andrews Castle. It was a trap, and Hamilton was immediately arrested, and after a show trial was sentenced to be burned at the stake. His execution took place on 29 February 1528 when, at the age of just twenty-four, Patrick Hamilton was chained to the stake above a small pile of wood in front of St Salvador's Chapel in St Andrews. Having refused to deny his Protestant beliefs, which would have brought the small mercy of being choked to death with a garrotte first, the fire was lit and Hamilton suffered a six-hour ordeal until his body eventually succumbed to the flames.

Any plans Archbishop Beaton had to quell the Protestant uprising also went up in flames on that day. Hamilton still had a lot of friends within the town, particularly among the student population, and watching their friend suffer so horrifically only served to fuel the Reformation. John Lindsay, a close friend of Beaton, is said to have warned him in a letter shortly after: 'If you burn any more

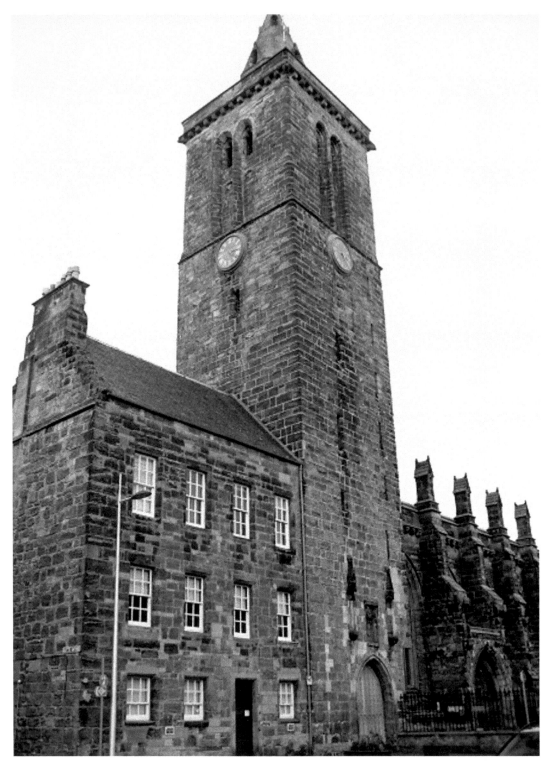

The tower of St Salvator's Chapel in St Andrews.

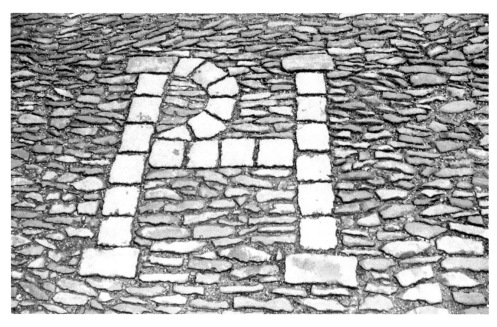

Patrick Hamilton's initials remain in the cobbles to mark the spot where he was burned alive.

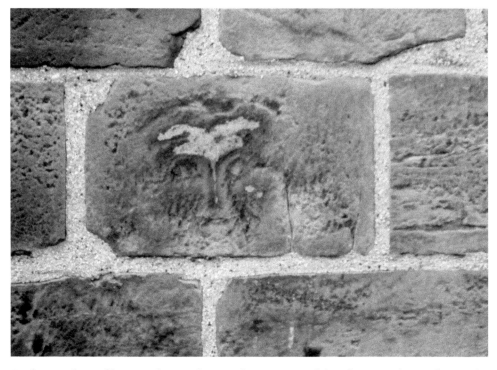

Such was the suffering of Patrick Hamilton, it is said his face was burned into the stonework of St Salvator's Chapel tower.

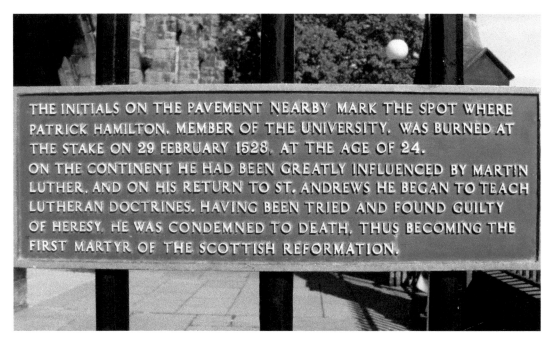

THE INITIALS ON THE PAVEMENT NEARBY MARK THE SPOT WHERE PATRICK HAMILTON. MEMBER OF THE UNIVERSITY. WAS BURNED AT THE STAKE ON 29 FEBRUARY 1528. AT THE AGE OF 24. ON THE CONTINENT HE HAD BEEN GREATLY INFLUENCED BY MARTIN LUTHER. AND ON HIS RETURN TO ST. ANDREWS HE BEGAN TO TEACH LUTHERAN DOCTRINES. HAVING BEEN TRIED AND FOUND GUILTY OF HERESY. HE WAS CONDEMNED TO DEATH. THUS BECOMING THE FIRST MARTYR OF THE SCOTTISH REFORMATION.

The memorial plaque at the spot Patrick Hamilton was burned to death.

you will utterly destroy yourselves. If you will burn them let them be burnt in deep cellars, for the smoke of Patrick Hamilton has infected as many as it blew upon.' This was a warning that proved to be correct.

Four years later, in 1532, Henry Forrest was burned at the stake, also in St Andrews, for being in possession of the New Testament. Many reports state that he was burned on the high ground above St Andrews Harbour, to ensure the flames would be seen across the water in Dundee to send out a warning to others to stay strong with their Catholic beliefs. Yet the country remained divided. As the Protestant movement got stronger, the persecution also increased, with many more facing horrific executions for their beliefs. It was again events in St Andrews that signified the beginning of the end for the rule of the Catholic Church in Scotland. Cardinal David Beaton succeeded his uncle as Archbishop of St Andrews in 1539 and such was his brutality in persecuting the reformers, many believed he was in league with the devil. Yet as both head of the Catholic Church in Scotland and a trusted member of the king's inner circle of advisors, few dared oppose him publicly. When James V died, leaving his week-old daughter, Mary, as the heir to the throne, Beaton produced a will signed by the king that appointed him as regent of the infant queen. When this was shown to be false and Beaton was discredited, he soon turned his attention back to the Protestants.

In 1546, a reformer named George Wishart rose to prominence. Wishart had spent time in England, a country that had already undergone a Protestant reformation after Henry VIII had disagreed with the Pope and taken action against the Catholic Church, leading to him being excommunicated by the Pope. With Wishart building an ever-growing following, Cardinal Beaton used his authority to keep the preacher being moved on from towns and cities in the hope that people would lose faith in him. However, Wishart would not be stopped, and having made a failed assassination attempt, Beaton had George Wishart captured and brought to St Andrews. In an act similar to the mistake his uncle had made with Patrick Hamilton, the cardinal had Wishart face a show trial in St Andrews Cathedral, where he was escorted by around 100 guards, and having been found guilty, he was sentenced to be burned at the stake.

The initials GW mark the place where George Wishart was burned to death.

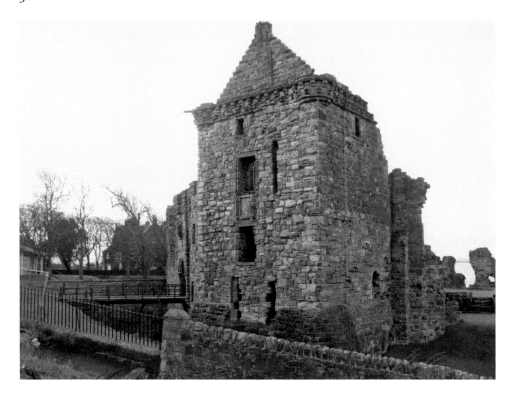

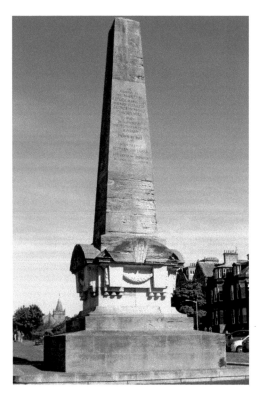

Above: The proximity of the window where Beaton sat to watch George Wishart burn.

Left: The Martyr's Monument in St Andrews.

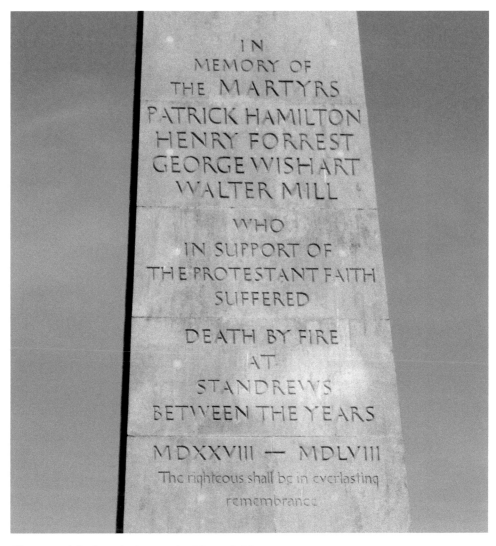

Close-up of the inscription on the Martyr's Monument.

George Wishart was executed the following day in front of the castle, with the whole event watched by Cardinal Beaton from the luxury of his personal apartments within the castle. Just as with Patrick Hamilton, George Wishart suffered horrifically. Yet such was his popularity, it was reported that even the executioner asked for forgiveness before he proceeded. Less than two months later, a group of ten of Wishart's supporters sneaked into the castle under the guise of workers carrying out repairs to the castle. Once inside, they secured the gates and proceeded to Cardinal Beaton's apartments, where he had locked himself in, only agreeing to open the door after threats were made to burn it down.

Once inside, Beaton was assassinated, and a year-long siege of St Andrews Castle began. The English army had began invading parts of Scotland in a period known as 'The Rough Wooing' as they tried to secure the marriage of King Henry's son to the young Mary, Queen of Scots, and the reformers hoped they could hold the castle long enough until the Protestant English forces arrived and they would be freed. Unfortunately, the Catholic French naval fleet arrived first, and after bombarding and destroying most of the building, those inside surrendered. Among those inside was a man named John Knox, a former bodyguard of George Wishart, who had joined the men in the castle to help them with their learning. Knox and the others were taken prisoner by the French and forced to become galley slaves, rowing the French warships, until 1549, when, possibly with the aid of the English government, John Knox was released and returned to England where he continued with his preaching.

When John Knox returned to Scotland in 1559, Queen Mary was living in France with a regent, Mary of Guise, ruling on her behalf. With the regent seriously ill and facing growing opposition from the reformers, Knox seized his opportunity to win the support of the English government and many of the Scottish nobles to finally convert Scotland to a Protestant country. A sermon delivered by John Knox in St Giles' Cathedral, Edinburgh, on 29 June, 1559, is seen as the starting point of the true Reformation, and following the death of the Mary of Guise in 1560, the treaty of Edinburgh was signed, which removed both the French and English forces from Scotland, leaving the way clear for the Scottish Parliament to ban the practice of Latin mass and to rule that it no longer recognised the authority of the Pope, which marked the formal approval of the Reformation.

DID YOU KNOW?
During the destruction that came with the Reformation, the remains of King Robert the Bruce were lost! In 1818, workmen were brought in to clear the rubble of the collapsed abbey tower, and as they worked they made a remarkable discovery of a body still tightly wrapped in a sheet of gold cloth. Tests revealed it was indeed the body of King Robert the Bruce, and the body was correctly exhumed and stored for twenty-two months before being reburied in the tomb he still rests in today.

The result across the country was mass destruction, and it was not long before this arrived in Dunfermline. The reformers attacked any buildings associated with the Catholic Church including the abbey, tearing down statues of the

saints from around the outside of the building and smashing the stained-glass windows depicting the saints. Wherever there were statues too high to be torn down, pieces of the carvings already smashed were used to throw at the statues to deface them. Dunfermline did, however, avoid the levels of destruction seen in other towns. In St Andrews, for example, both the cathedral and the castle, which was the residence of the archbishop rather than a structure built to defend the town, were torn down and the stone quarried. In Dunfermline, the connection to the monarchy saved the buildings from the same levels of destruction, and they were able to be repurposed for the reformed Scotland. While the old choir section of the abbey was allowed to collapse, the nave was saved and converted into a parish church for the people of the town. This required large buttresses to be added to support the walls, which were damaged during the Reformation and in a poor state of repair.

Most abbeys would also be expected to provide accommodation for any visiting royalty and their forces. Dunfermline Abbey was no exception, with the guesthouse believed to have been a royal residence. After the Reformation, this was extensively extended and, along with the west range of the abbey, a new palace was created, which became the personal residence for Queen Anne of Denmark, wife of James VI.

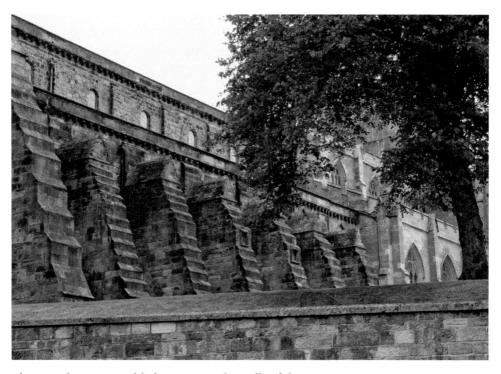

The stone buttresses added to support the walls of the nave.

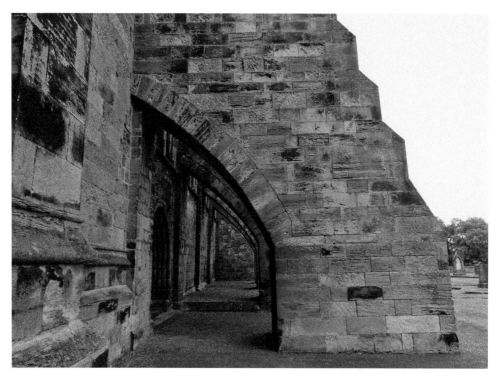

Looking down inside the stone buttresses.

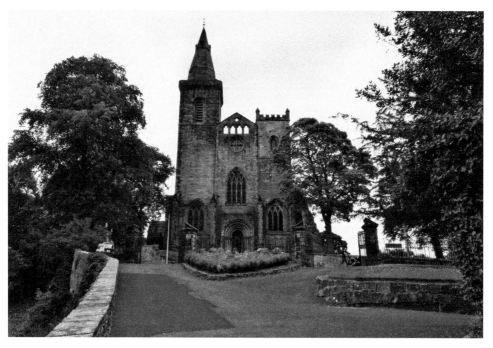

The approach to the abbey church.

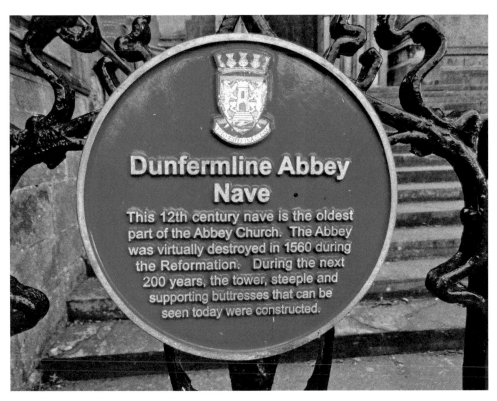

Memorial plaque detailing the reconstruction of the oldest part of the abbey church after the Reformation.

The Witch Trials of Dunfermline

The marriage of King James and Queen Anna led to one of the most barbaric times in Sottish history. After a proxy wedding in Copenhagen, a wedding at which neither party were present, Anne set sail for Scotland. Her fleet encountered violent storms on the way and were forced to turn back and land in Norway. When word reached King James, determined not to be separated from his new bride any longer than necessary, he decided to set sail himself to collect her and, accompanied by an entourage of around 300 advisers and assistants, departed from Leith docks. The couple were formally married in the Bishop's Palace in Oslo in November 1589, before travelling back to Denmark. It was here that the king was to hear about the study of witchcraft, with the courts of Denmark already having dealt with several trials of accused witches. When the couple returned to Scotland in May 1590, their journey was again hampered by great storms that seemed to rise out of nowhere. This were two attempts to sail from Denmark back to Scotland that had almost resulted in disaster, and an investigation was launched, with a Danish minister being suspected of under-supplying the ships, making the unstable in the storms. He bizarrely claimed that it was witches, who met in the house of Karen the weaver, who had sent imps to load empty barrels onto the ships. Even more bizarrely, this claim was followed up on, a clear indication of the belief in witchcraft of the time, and Karen soon gave the names of the women alleged to be witches, the main one being a women called Anna Koldings, who became known locally as the 'Mother of the Devil'. Under torture, she confessed to the meetings with Satan, and to have cast spells to cause the storms to try to sink the ships of Queen Anne. As a result of the trial and confessions, Anna and up to twelve other women were put to death by burning for witchcraft.

When word reached King James of the successful trials, he started his own, which became known as the North Berwick Witch Trial, the first major witch trial after the Witchcraft Act of 1563, which had been made law by the Scottish Parliament under the control of his mother, Mary, Queen of Scots. A herbal healer from Nether Keith in East Lothian, known as the 'Wise Wife from Keith', became the prime suspect, and was interrogated along with around seventy other women. All confessed under torture to meetings with the Devil in the churchyard at North Berwick to plot to kill the king, with Agnes being singled out as the ring

leader. It appears Agnes was better educated than the others, according to the 1830 book *Letters on Demonology and Witchcraft* by Sir Walter Scott. She was described by Archbishop Spottiswood as being 'not one of the base or ignorant class of ordinary witches, but a grave matron, composed and deliberate in her answers, which were all to the same purpose', which is possibly why the finger of suspicion was pointed at her.

DID YOU KNOW?
There once stood a massive stone boulder at the side of the old road between Crossford and Cairneyhill. Descriptions say the stone was around 18 feet long, 21 feet deep and 5 feet tall. The stone became known locally as the Witches Stone, and folklore told that it was carried there by a local witch. Wanting to give the Pitfirrane family a gift, she had lifted the boulder from the shore and carried it in her apron, but before she could reach the Pitfirrane family home, her apron springs broke and the stone lay forever after where it fell. What the origin of the story was is not known, but it seems both the rock and the legend caused some issues for the farmer. In 1972, explosives were placed in the stone and blew it up. Not content, the larger remaining fragments were then also blasted and nothing now remains.

Agnes suffered horrific torture, much of which was overseen by King James himself. Eventually, in the presence of the king, she broke and confessed to all the accusations made against her. She was sentenced to be burned at the stake, with the only mercy being she would be garrotted first before the fire was lit. King James became obsessed with the threat of witchcraft and the dark arts, leading to him writing the book *Daemonologie* in 1597. He continued to supervise the torture of the accused whenever he could, although by the start of the seventeenth century it was said he was starting to move away from his belief in the power of magic.

The Witchcraft Act on 1563 had been introduced under the reign of Mary, Queen of Scots. It served two purposes: firstly, it was designed to stamp out any remnants of the old Celtic traditions such as using herbs as medicine and failing to attend church at the required times, which were considered sufficient evidence for arrest and trial as a witch; the second intention was to try to quell the Protestant Reformation, which brought new rights to women as individuals. With the threat of becoming a more prominent member of the community resulting

in women coming to the attention of the Witch Watchers, the intention was to encourage women to remain in their old submissive role and retain the Catholic religion. With the Reformation becoming law, more women were encouraged to pursue their new freedoms and the Witchcraft Act became a good way for those with any authority to pass blame for their misdemeanours on to others, and for towns to rid themselves of anyone that was unpopular or simply didn't fit in for whatever reason. As the Reformation took grip, people, businesses and even whole towns who had relied on the Catholic Church for employment and trade fell into poverty. Desperate people would take desperate action, and fuelled the allegations of the Devil being at work. As a result, the witch trials continued for a further century.

Possibly the earliest witch trial in Dunfermline was that of Auld Bessie Bittern, or Boswell. Said to be a woman not to cross or disagree with, and muttering what was taken to be curses to anyone who caused her any frustration, it was inevitable that locals would begin to suspect her as being a witch, and the addition of her large black cat did nothing to quell people's fears. According to the story told about her, she approached a local weaver named Johnnie and asked him if he would be able to dig some potatoes for her the following morning. On hearing the request, Johnnie's wife interrupted and explained that he needed to get cloth made for an order, and would not have time. Objecting to her interference and opposing her, Bessie replied that not digging her potatoes will not allow him to get the cloth made any quicker. Johnnie suggested it would be better if he simply went to dig some potatoes, which would not take long, and he could then get on with the weaving, but his wife stood firm in her refusal. Bessie expressed her annoyance at her refusal to allow her husband to help her, a poor old lady, and assured her she would not be any richer from her refusal before leaving the shop followed by her cat.

The following day Johnnie returned to work on the cloth he was weaving, but as soon as he started, his shuttle flew from his hand and landed on the floor. He picked it up and tried again, only for the shuttle to again fly from his hand. After repeated attempts, the meaning of Bessie's words fell into place. He had been bewitched and was unable to weave, meaning that the refusal to dig her potatoes would neither make the cloth be finished quicker, nor make them any money. In an attempt to break the spell, he took the shuttle to the kitchen fire and drew it through the flames three times. It is not recorded whether this worked. Bessie was arrested for witchcraft and banished from Dunfermline as a result. She was fortunate in that the full effect of the Witchcraft Act of that year was not implemented.

Initially some local opposition remained against the Witchcraft Act. In 1614. The Earl of Dunfermline, Lord Chancellor of Scotland, intervened in one case, ruling that unqualified witnesses could not be heard. As a result, the prosecution could not submit the evidence from their fourteen witnesses, and the case was

dismissed. As the witch frenzy continued to sweep across Scotland, witches were first found in Dunfermline in 1627 and in 1640, and a new town executioner named Pat Mayne was appointed. His title of hangman and witch burner sent out a rather ominous message of his intentions, and during his time in service, he became known as the 'Notorious' Pat Mayne. In addition to the witch burner, the town appointed witch watchers, who were responsible for observing the people of the town and looked for anything unusual or any failure to attend church. Witch catchers were also appointed, who, as the title suggests, would seize and imprison all suspected witches until they could face trial. The threat of being accused of witchcraft was enough to make almost everyone adhere to the town's rules and attend church as often as possible out of pure fear. Of those accused, the more wealthy and influential could often buy their way out of trial and receive only a short imprisonment and reprimand from the Church. Others may be lucky enough to have wealthy supporters, who secured their release, although the accused was likely to be banished. For others it was certain death.

DID YOU KNOW?
A witch trial could be very expensive. An invoice for the costs for a case is Kirkcaldy is available in multiple publications as follows:

Expense incurred for the Judge: 6s
Payment to the executioner for his pains: £8, 14s
Executioner's expenses: 16s, 4d
Hemp coats: £3 10s
Making of the above: 8s
Hangman's Rope: 6s
Tar Barrel: 14s
10 loads of coal: £3, 6s and 8d

Fortunately in this particular case, it is said that the cost was split between the town officials and the church, but for an ordinary family, it would be very difficult to raise these funds.

Natural incidents such as crops failing, storms, floods, illnesses and deaths were blamed on witchcraft. A natural fossil known as a gryphaea was a common find on the beaches of Fife. Formed from an extinct species of oyster, these look very much like a claw, and became known as 'Devil's Toe Nails'. Finding one on

the beach was seen as proof that the Devil was in the area, casting his influence on the weak-minded to direct them to witchcraft. People could even use witchcraft to get rid of people they did not like by making simple accusations such as saying they appeared in their dream and threatened to kill them. The ordinary townsfolk were genuinely terrified, as the slightest mistake or fall out could result in them being thrown in jail as a witch.

The treatment of the accused is unimaginable today. With nothing more than hearsay, they would be asked to confess their crimes as a witch. Refusal resulted in torture, as a confession under torture was acceptable. Other than for those with influence, as mentioned earlier, the friends and family of the ordinary man or woman (although most accusations were made against women, some men also faced trial) of the town were unable to help. The witchcraft Act of 1563 included the following wording:

> Nor that na persoun seik ony help, response or cosultatioun at ony sic usaris or abusaris foirsaidis of Witchcraftis, Sorsareis or Necromancie, under the pane of deid, alsweill to be execute aganis the usar, abusar, as the seikar of the response or consultatioun.

The consequence of the above was that anyone who was found to help, speak to or consult with someone later found to be guilty as a witch would be executed with them. It was a hopeless situation for many.

Those accused of witchcraft were not allowed to sleep, often being walked round their prison cell by a guard pulling a rope round their heads. The guards would work on shifts, ensuring there was no let up for their prisoner. When they were left, they would be tied in the most uncomfortable positions, or have devices such as the Witch Forks, a sharp spike attached to a metal collar that forced you to hold your head tilted backwards, designed to prevent sleep. Devices such as the thumbscrews or the 'Booties' were also used. The booties consisted of basically a metal or wooden boot, which would go up to around your knee. Once your foot and lower leg were within, wooded wedges would be hammered in, slowly compressing the limb until it shattered. In addition to the other roles created to enforce the rules of the Witchcraft Act, a new type of torturer came to light. Known as the 'witch prickers', they would travel from town to town with the sole purpose of finding witches. It was believed that a small mark on the body, such as a mole or birthmark, was evidence that the Devil had removed your faith. If no mark could be found, the possibility of it being inside your body had to be explored. As the area around the mark was the Devil's work, it was said that it would be impervious to pain, and so the prickers' tool of the trade was a long, sharp spike that he would slowly push through the skin into the body of the accused, covering the whole body, inch by inch. They would look for a spot where

there was no reaction to pain, yet were skilled in knowing how to numb nerves as they went, so they would eventually create a spot where no pain would be felt. Witch prickers were paid by the hour, and so it was not in their interest to end the process quickly. Once a confession was made, the convicted witch would be required to name the other women in their coven, who would be arrested and the process would start again. The family of those convicted would then be billed for their loved ones time held in jail, the jailor's time, the witch prickers' time and even the rope, wood and tar used for the execution. Most found a way to pay, as failure would result in an accusation of aiding the witch, and this brought some much needed money to the local authorities.

In Dunfermline, the area going towards Townhill was where the accused witches were executed. The street named Witchbrae off Bellyeoman Road is a small reminder of the days gone by, yet other names have been lost, either through natural changes to the townscape or by deliberate action to try to bury the past. The upper end of Townhill Road was once known as Witch Loan, and in the area where it turns into Kingseat Road, there was a small hill known as Witch Knowe, and just to the north stood the gallows. This was the execution site, outside the then town boundaries with the belief that this would prevent the vengeful spirits of those executed from wreaking their revenge on the townsfolk. Around half way up Witch Loan, two other sites associated with the witch trials also stood. A witch pool sits in the gardens of a private residence, although the reason it bears the name 'witch' is unclear. It should be noted, however, that that not all witch trials are documented, and while the University of Edinburgh has compiled the most complete records available in their 'Survey of Scottish Witchcraft Database', some details remain still lost to time. On the opposite side of the road was another pool known as the Witches Dub. Believed to measure approximately 30 yards in diameter and be between 6 and 10 feet deep, this is where the practice of 'dooking the witch', or witch swimming, was said to have taken place. Although this method of trial was relatively scarce in Scotland, as with most methods connected to witchcraft, it was a no win situation. The accused would be thrown into the pool. As water is pure, if it accepted them they would sink. They would be declared innocent, but would drown. If they floated, it was said the water was rejecting them as their soul was not pure, and they were burned as witches. To add to the suffering, in Scotland it is often stated that those about to be tested would have their right thumb tied to their left toe and their left thumb tied to their right toe, thus forming the cross of St Andrew. By the end of the eighteenth century, the Witches Dub had been filled in, and it is unlikely anything remains of it today.

The year1643 is referred to in historical books as a great witch-catching and witch-burning year in Dunfermline, with a large-scale persecution no doubt overseen by Pat Mayne. The witch watchers and catchers had been appointed

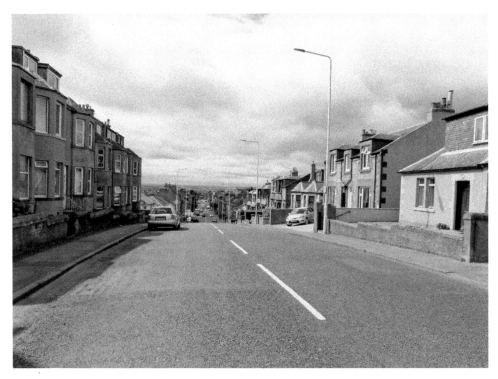

General view down Townhill Road, formerly known as Witch Loan.

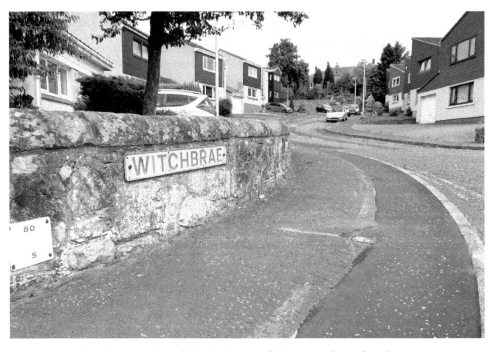

Witch Brae, the only reminder of the dark past of this part of Dunfermline.

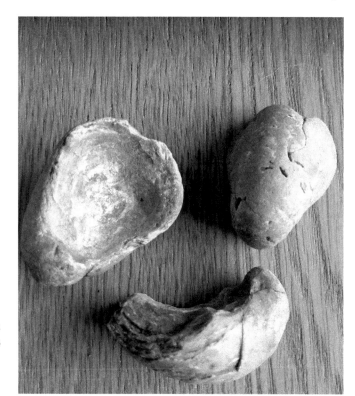

The natural fossil known as a gryphaea, which was thought to be the claws of the devil and proof that evil was in the area.

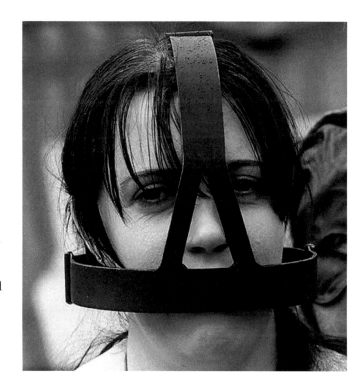

The Scolds Bridle. This method of torture enclosed the accused's head in a steel cage with a strip of metal, often with a spike attached, which would be inserted into the mouth to prevent the wearer from talking. (Courtesy of History and Horror Tours, Aberfeldy, Perth)

earlier in the same year, and to prove their worth they are said to have rounded up a great many shrivelled up old women – if they walked using a long staff, that was even better for the evidence! Of those accused, Jonett (Janet) Fentoun Marr died in prison on 20 June 1643. Although there does not appear to be any documentation surrounding the cause of her death, it is highly likely that this was as a result of injuries sustained during torture. Such incidents always caused some issues for the town authorities. The women had not been found guilty of witchcraft, and so their bodies could not be officially burned, yet with them still being under suspicion of witchcraft at the time of death, it would not be right for them to be given a full Christian burial. The records show that Jonett's body, rather unceremoniously, was dragged from the prison and up Witch Loan. Soon, a cart was located, and she was thrown into that and pulled up to Witch Knowe, where she was thrown into a hole with no coffin and buried.

On 17 August, another of the accused, Isobell Marr, committed suicide in jail by hanging herself. Again she was carted up to Witch Knowe and buried in an unmarked grave with no ceremony or tributes, simply to be forgotten. Over a three-month period, a further six women were found guilty of witchcraft. Grissel Morris, Margaret Brand, Katherine Elder, Agnes Kirk, Margaret Donaldson and Isobel Millar all perished in the flames at Witch Knowe, all because they did not fit into societies expectations of the time.

A later witch trial that has reached the news in recent years is that of Lilias Adie. Lilias lived in the small village of Torryburn, around 7 miles west of Dunfermline town centre, where the local minister, Revd Allan Logan, was known to be one of the most successful witch finders and prickers in Scotland. His reputation was such that during his weekly sermons, he would regularly suddenly stop and stare angrily towards the congregation before pointing his finger towards someone and shouting, 'You, Witch! Rise and be gone from the Tables of the Lord.' On almost every occasion, one terrified elderly woman would think he was pointing at her and stand to leave the church, only to be arrested outside by the local baillie and taken by armed guard to the jail to await trial.

Lilias was accused by her neighbour, Jean Nelson, of bringing her ill health, and was taken to the church to face the minister and elders and plead her case. Faced with such a feared witch hunter, Lilias freely confessed. It was apparent she was confused, terrified and really did not know what was happening and so said what she thought she needed to in order to get out of the situation. When pressed, she came up with a story that she had been approached by a man, who later turned out to be the Devil, in a cornfield. She said that having discovered the stranger's true identity, she accepted him as her master and lover, and aided in luring other women to him, who were led to the cornfield by a strange blue light that brought them to the Devil. Lilias was imprisoned awaiting trial, and official records from the time state that she was burned at the stake at the seamark on

Torryburn Beach. This was not the case, however. Lilias in fact died in jail before her trial in Dunfermline jail, possibly by suicide once she realised the gravity of her position. Again the situation arose of what to do with her. She had confessed to being a witch, but had not faced trial and been found guilty. A decision was made to bury her on the beach between Torryburn and Torrie. Witches were believed to not be able to cross moving water, and so the constant movement of the tide would prevent her from rising from her grave, although as an extra precaution, a large stone slab was placed above her body to weigh it down.

That was not the end of her story. During the nineteenth century, with beliefs changed and the story of Lilias giving an opportunity to own rather morbid, yet unbelievable rare relics of these brutal times, her body was dug up and parts of her were put on sale to antiquarians. It is known that her skull went to St Andrews University, where it was studied, but its location is unfortunately no longer known. Their research did, however, reveal that Lilias had very prominent buck teeth and was around seventy years old when she died, a very old age for that time, two possible reasons for suspicion falling upon her. In 2014, spurred on by the descriptions of the location of her grave and the 'great stone doorstep'

The shoreline close to Torryburn, the general area where Lilias Adie was buried. (© William Starkey (cc-by-sa 2.0))

The stone that marks the burial spot of Lilias Adie. (Photo supplied by Fife Council Archaeology Department)

that lay on top, a small group led by Fife Council's archaeologist Doug Spiers set about finding her grave. Their search was successful, and it is believed that although some of her body was taken, much of Lilias still remains under the stone slab. Local news reports once again brought the story of poor Lilias Adie and the horrors of the witch trials to the public attention.

To balance this section of the book, it is only fair to also tell you what happened to the Revd Allan Logan. He succeeded his brother in the Estate of Logan in Ayrshire in 1727, and upon his death in 1733, he left a significant sum of money to the poor of Torryburn and Culross. Although his act of sending many innocent women to their death could not be undone, it seems he had realised he had been wrong and took steps to try to make some recompense to the local community.

Fife Council archaeologist Douglas Speirs inspecting the marker stone. (Photo supplied by Fife Council Archaeology Department)

Close-up of Lilias Adie's marker stone. (Photo supplied by Fife Council Archaeology Department)

The Great Fire of Dunfermline

With parts of the town in ruin after the Reformation and the loss of the benefits that came with being an ecclesial centre, Dunfermline was to face a further blow to its fortunes in 1603. Elizabeth I of England died, unmarried and with no children, leaving the English crown to pass to the next in line to the throne, her cousin, James VI of Scotland. The Union of the Crowns may have led many in Scotland to feel some rejoice. The kingdoms of England and Scotland had fought to achieve unification for over a century, and now it had been achieved through fortunate circumstances, with the King of Scotland taking both crowns. Any celebrations would, however, be short-lived. King James sought to have a complete union between the countries rather than just a united crown, and to do so he would need the support of both the English and Scottish parliaments. After making his intentions clear, he travelled to London and relocated his royal court there. Dunfermline had lost its royal connection, and the town quickly fell into decline.

DID YOU KNOW?
A week before the Great Fire, it was said a number of rats were seen making their way up Rotten Row. Although rats were common in these times, what was notable is that two of the rats were running side by side each holding an end of a piece of straw in their mouth. Between them was what appeared to be a blind rat, also holding onto the straw so it was being guided by the other two. After the fire, recollections of this incident were made and speculation that the animals could sense that disaster was coming, and so fled, looking after each other as they went.

The downfall of Dunfermline was, in no doubt, instrumental in the witch hunts that arrived in the town afterwards. King James did not return until 1617, when he stayed for a few days in May and June, and while he was met with joyous crowds, he had no intention to re-establish his connections with the town and was merely passing through.

On 25 May 1624, the town was devastated by fire. That day was Wappinshaw day in Dunfermline, the name traditionally given to the day when all the troops and volunteer riflemen gather to allow the weaponry to be checked and the competence of the men to be verified. One of the guns was discharged and some burning wadding fell from the gun onto the thatched roof of a house in Rotten Row (rebuilt as Queen Anne Street). With most of the buildings of the town being of simple wooden constructions with thatched roofs, little space between them and a strong wind blowing that day, the fire spread rapidly. Enquiries afterwards soon revealed it was a local man named William Anderson who had fired the gun, the son of the Baillie of Dunfermline. The fire started around noon and burned for around four hours, with around three quarters of the town, which had consisted of 220 houses containing 287 families, being destroyed. Later reports indicate that almost the entire town was in fact lost. Such was the damage, the Privy Council visited a few days later to give a direct report to King James.

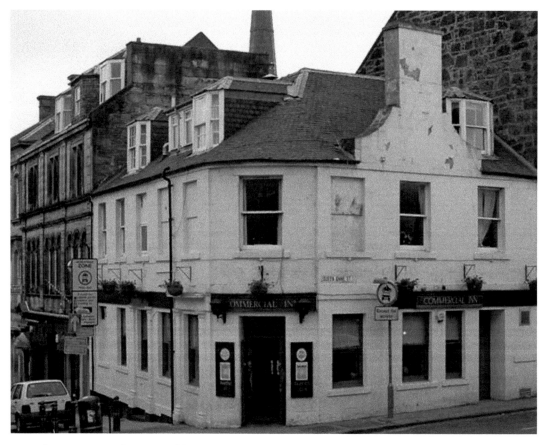

The Commercial Arms public house stands in the corner of Queen Anne Street, close to where the Great Fire of Dunfermline started. (© Paul McIlroy (cc-by-sa 2.0))

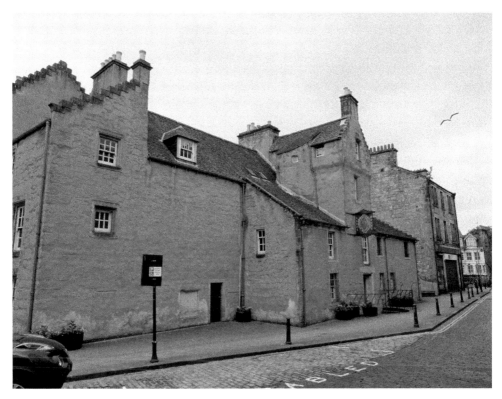

Above & below: The distinctive Abbot House was one of the few stone buildings in Dunfermline at the time of the fire that survived the flames.

The population of Dunfermline at the time was around 1,600, with 320 children aged six years or under, and with so many families made homeless, urgent action was needed. Orders were immediately issued that all those in a financial position to do so were to immediately start rebuilding their homes. The burgesses of Dunfermline held the rights to cut wood from the estate of Garvock, which was only a mile or so from the town, and so a plentiful supply of wood was made available for the rebuilding. Benevolence funds were set up and contributions made from towns and cities across the country to assist those unable to pay for the rebuilding of their own homes. Aberdeen alone is documented to have raised 1,600 Scots merks, a sizeable amount of money at the time. The extensive rebuilding work also created an abundance of work in the town. The ground floors were generally reconstructed using stone, with the ruined religious buildings left from the Reformation providing a ready supply of materials, and the upper floors were constructed from timber. By the end of the rebuilding, Gaverlock Hill had been stripped almost entirely of trees.

DID YOU KNOW?
It is thanks to the Great Fire that such accurate details are known about Dunfermline's population. After such devastation, the exact number of men, women and children needed to be recorded to allow some priority to be given to those deemed to be in greatest risk. It is unusual to have this information available until later in history.

Strangely, details of the fire are relatively scarce and facts are difficult to come by. Had it been an ordinary member of the public who had fired the gun, it is likely they would have faced severe punishment for the devastation they caused. Details of what happened to the money received in benevolent funds do not appear to be available. What details are known come from other towns' records, and clearly indicate large sums of money were given. Rather unusually, towards the end of 1624 there was a significant rise in the number of people being summoned through the courts for non-payment of rather small sums of money, mainly for stone, lime, timber and labour. If the benevolent funds had been fairly distributed it is difficult to understand the reasons for these actions, as these minor debts should have been covered. It is therefore difficult to avoid the thought that there was some form of cover-up

over the fire. Whether this was to protect the baillie's son, or to allow the benevolent funds to be syphoned off and used elsewhere instead of for their original intention, or both and more, it is impossible to say. In the 1600s it was relatively easy for the authorities to ensure records went astray, or reflected matters as they wanted them to be seen, and so the truth of what happened is unlikely to ever be found.

Recovery of the Town

There were a few periods of Dunfermline's history when it was hoped that there would be a resurgence in the town. The palace remained a royal household and Charles I was born there in November 1600. He lived in Dunfermline until 1604, when he was transported to London to join his family, and he would stay in England for most of his life. Charles II was the last monarch to use Dunfermline Palace in 1651, after which it was considered to be surplus to requirement and simply left to fall into a state of disrepair. By 1694, the burgh debt was estimated to be 5,573 Scottish merks, and in the eighteenth century the English author Daniel Defoe, famous for his writings such as *Robinson Crusoe*, visited Dunfermline and described the town as showing the full perfection of decay. It is difficult to say whether these comments was intended as a compliment or an insult, but, either way, it reflected to sad state Dunfermline had fallen into.

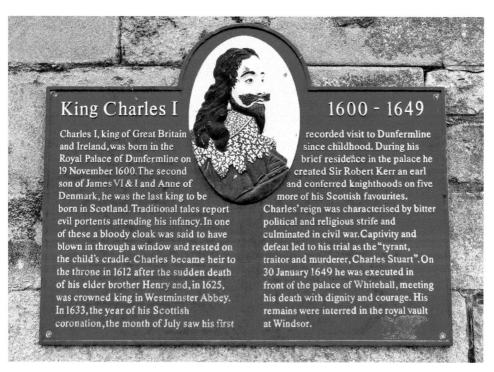

Memorial plaque for Charles I.

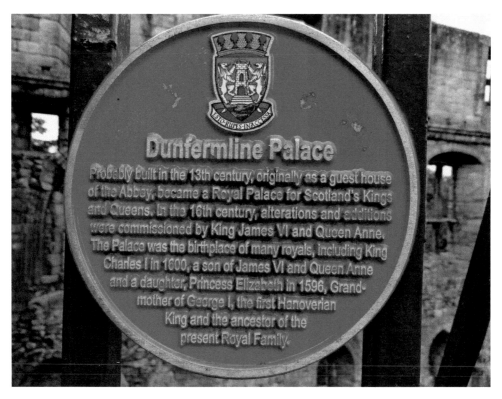

Plaque providing details for Dunfermline Abbey.

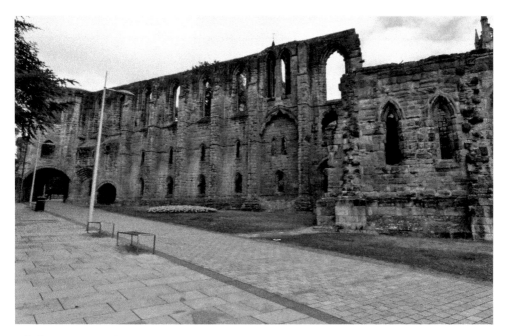

All that remains of the Royal Palace today are some ruins.

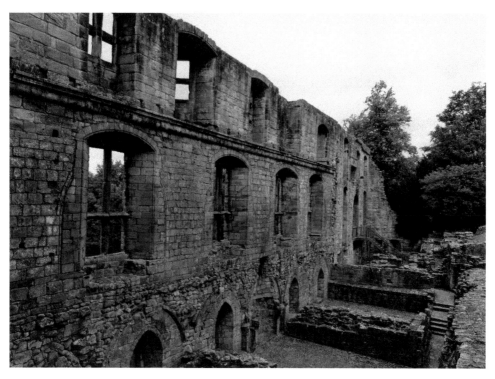

The ruins of the Royal Palace.

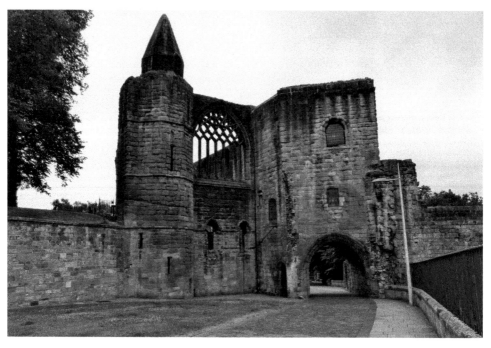

The Pends Gatehouse to the palace, where Dunfermline's Damask linen industry first started.

However, Dunfermline was to once again rise in status thanks to the linen industry moving to the town. Around 1715, Damask weaving had been introduced to Edinburgh. Damask is based on a relatively simply form, yet built upon to create a complicated weave that is reversible, normally made of wool, linen, silk or cotton. This was a highly desirable cloth, and access to the building in which it was woven was strictly restricted to keep the methods secret. The exclusivity around the weave ensured it could command high prices, and it was the subject of much discussion among weavers up and down the country, who all desired the knowledge to make it and to take a piece of the lucrative market for themselves. A young weaver from Dunfermline named James Blake was a gifted mathematician with a deep understanding of mechanics. In addition, he had an almost photographic memory, and he set about gaining access to the factory where Damask linen was made. To do so he pretended to be of low intelligence and started meeting with the workmen telling them daft tales. Seeing him as no threat but of good entertainment value, he was eventually allowed into the factory to keep the workers amused as they worked. It seems even then there was an understanding that a happy worker is a productive worker. He proceeded to spend time studying the mechanisms and methods as he continued to tell his stories to the unsuspecting workforce.

DID YOU KNOW?
Although Dunfermline is best known for its Damask tableware linen, the town's weavers had been looking for new items to create before the Damask industry came to the town. By the start of the 1700s the weavers had already worked out how to make seamless skirts on their looms, and in 1702 they produced a seamless shirt, believed to be the first of its kind.

Soon after, he returned to Dunfermline with every detail of the production process of Damask linen secured in his mind. He drew plans for the loom required, and had this manufactured and set up in an empty room in The Pends, the gatehouse for the abbey.

In the summer of 1718, he began to weave Damask linen, and he was soon joined by John Beveridge and John Gilmour, also weavers, until every room in The Pends was filled with Damask looms. Other weavers moved to Dunfermline to also specialise in Damask. Their main manufacture was table linen, specialising in the crests and flags for those of influence, and demand grew. By the 1760s

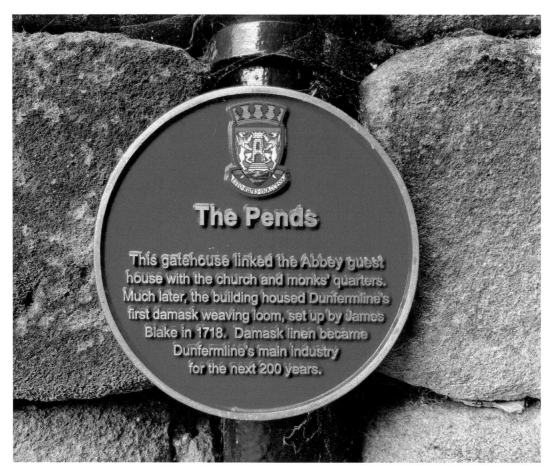

The Pends

This gatehouse linked the Abbey guest house with the church and monks' quarters. Much later, the building housed Dunfermline's first damask weaving loom, set up by James Blake in 1718. Damask linen became Dunfermline's main industry for the next 200 years.

Memorial plaque to the origin of the Damask linen industry.

it was estimated that there were between ten and twelve looms in the town producing table linen. By 1788 there were around 900, growing to 1,200 by 1792 and 1,700 looms in operation in both Dunfermline and the surrounding area by the early 1820s, with the table linen industry in Dunfermline producing around £100,000 worth of goods a year.

Table linen was not, however, the only weaving taking place in the town; spinning mills also provided employment for many people. The Brucefield Spinning Company was the oldest, which employed around 200 people in its heyday. The Mid-Mill had between forty and fifty workers at any one time, producing yarn predominantly for the table linen trade. Harey Brae Mill produced any different types of yarn, employing around 200 men, women and children, and both the Mill-Port Spinning Mill and the Clay-Acres Spinning Mill provided employment for around fifty people each.

The former St Leonard's Works. This linen mill has now been converted into flats. (© Paul McIlroy (cc-by-sa 2.0))

St Margaret's Works on the north side of Foundry Street. (© Paul McIlroy (cc-by-sa 2.0))

Pilmuir Works on the west side of Pilmuir Street. (© Paul McIlroy (cc-by-sa 2.0))

Foundry Street separates St Margaret's Works and Pilmuir Works, although the two linen factories were connected by a high-level bridge. (© Paul McIlroy (cc-by-sa 2.0))

The Victoria
Works, also
situated on
Pilmuir Street.
(© Paul McIlroy
(cc-by-sa 2.0))

The Victoria Works of Castleblair Ltd being converted into apartments. (© Robert
Struthers (cc-by-sa 2.0))

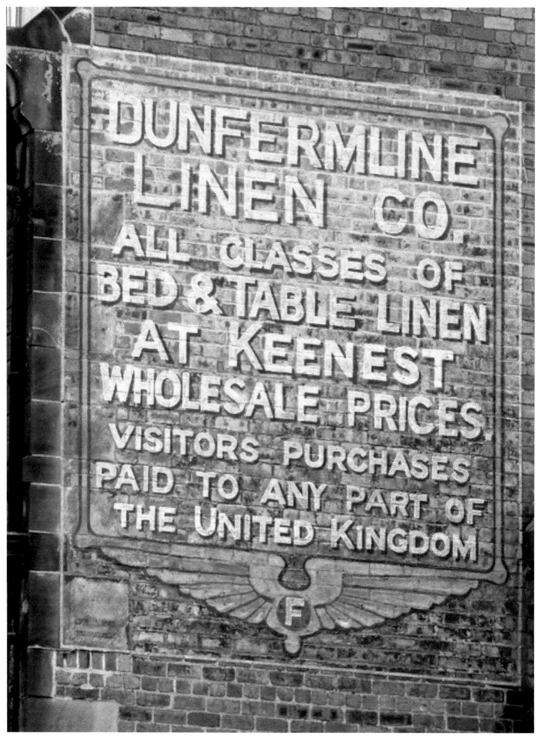

A painted sign remains on the gable wall of a property in New Row advertising the Dunfermline Linen Society. (© Thomas Nugent (cc-by-sa 2.0))

By the late 1820s, everything had changed. Power looms began to be introduced that could produce vast quantities of linen to any design much quicker and with a more consistent standard than that produced on the handlooms. Imported linen from the German factories began to swamp England, particularly London, which was one of the main markets for the Dunfermline Damask. The result was massive stocks of unsold linen piling up, and production being slowed until this could be sold. The linen industry in Dunfermline took this time to plan for the full effect of the coming Industrial Revolution, and large steam-powered factories started to be constructed to maintain the industry. By the end of the nineteenth century the Damask linen of Dunfermline was considered to be of the highest quality, almost unequalled in the world.

At the start of the twentieth century, with the growing threat from Germany, the Royal Navy began constructing larger and heavier ships, yet this in itself caused a problem. The only naval dockyard on the east coast at Chatham in Kent was not deep enough to accommodate the new ships, and those on the south and west coast were deemed too far away to launch ships to the North Sea. The location for a new base was sought, and in 1903 an area of almost 480 hectares of land and 115 hectares of foreshore were purchased at Rosyth, by Dunfermline. Rosyth offered deep waters leading directly out to the North Sea via the mouth of the Firth of Forth, yet was also relatively sheltered due to the surrounding landscape. Work began in 1909, which brought mass employment to the area, with new supply railway lines being constructed from the surrounding areas.

When the First World War broke out in 1914, the base was not complete and only the outer basin could be used for warship repairs. Construction of the workshops and the fuel oil depot took place during the war years, as did construction of the town of Rosyth, built as a garden town to house the workers at the base and associated trades. In 1919 the base was completed and at its peak it employed over 6,000 people. However, after the First World War work started to dwindle, and in 1925 the base was closed and placed under a care and maintenance contract the following year.

DID YOU KNOW?
The first warship to enter the main basin in Rosyth Dockyard was HMS *Zealandia*. She sailed through the emergency exit into the berthing in March 1916 for repair to damage sustained at the Battle of Jutland, and this symbolised the dockyard becoming fully operational.

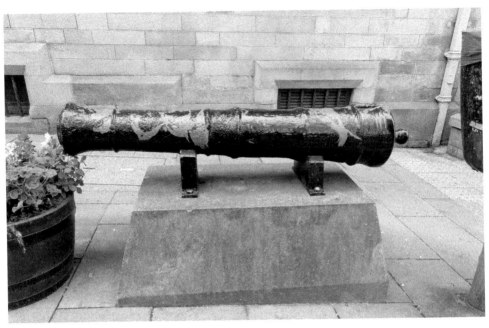

In the eighteenth century there were also a number of iron foundries operating in Dunfermline. The Carron Iron Works gifted a canon to the town when submitting an application to open a new foundry. Despite the generous gift, the application was turned down to protect the other foundries, and the canon has sat outside the Town House since 1772.

Old meets new at Rosyth Shipyard with modern equipment towering over the old stone buildings.

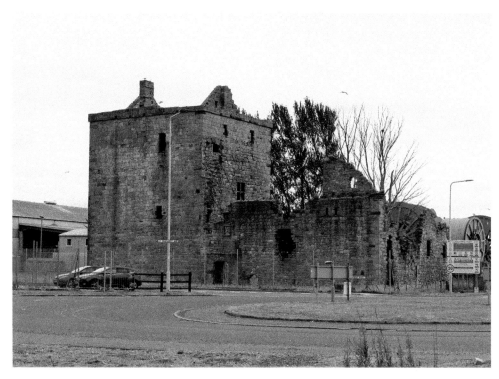

The ruins of Rosyth Castle are now surrounded by the dockyard.

Part of Rosyth Dockyard from the opposite side of the Firth of Forth.

Part of Rosyth Dockyard from the opposite side of the Firth of Forth.

Andrew Carnegie

It would not seem correct to write a book about the history of Dunfermline without covering one of the town's most famous names.

Born in 1835, Andrew Carnegie can perhaps thank the linen trade of Dunfermline for the opportunities that opened up to him. His father, William Carnegie, was a handloom weaver working in Dunfermline, who came from a family with a strong belief in education and politics. One of the most influential people in young Andrew's life was his uncle, George Lauder, who owned a grocer shop in the town. It was his Uncle George who would tell him about Scottish history and the writings of the poet Robert Burns.

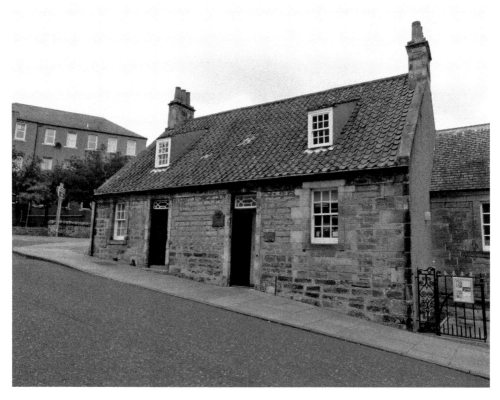

The house in which Andrew Carnegie was born and raised. This now forms part of a museum.

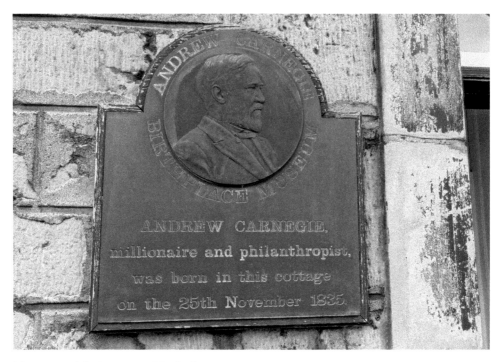

The memorial plaque outside the house.

The statue of Andrew Carnegie at Pittencrieff Park.

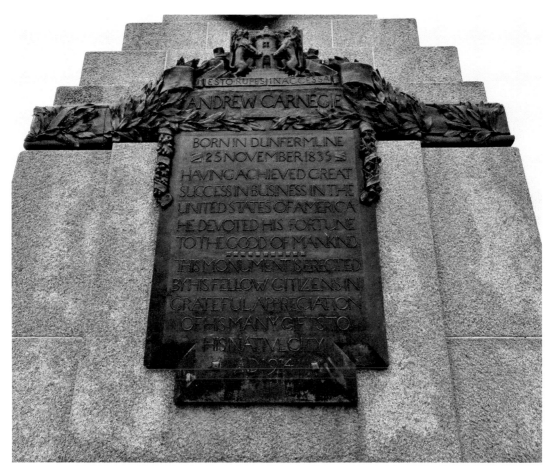

The plaque on the statue of Andrew Carnegie.

By the 1840s linen production had moved to the large-scale steam-powered factories, and William Carnegie found it increasingly difficult to find work in these factories due to being known as a bit of an activist. A relative had also been arrested in 1842 for taking part in strike action, which did not help his reputation as being someone who could cause difficulties for the factory owners by defending workers' rights. In 1848, he made the decision to emigrate to America, and they set up home in Pennsylvania where both William and the then thirteen-year-old Andrew found employment in a local cotton mill. Andrew's ambition to learn remained, and he took his education into his own hands, studying in the local library every Saturday night. After leaving the employment of the mill, Andrew took up employment with the Pennsylvania Railroad Company, where his drive and ambition saw him rise quickly through the ranks to become a superintendent.

Perhaps from his knowledge of Scottish history, Andrew could see opportunities in the up-and-coming American states, and saved and invested what money he could in industries associated with the growing railroads, including a steel rolling mill. This signified the start of a journey that would take him to great places. As his investments started to provide significant returns, he continued to invest heavily into the steel industry, and actively encourage the rail networks to replace their wooden bridges with steel bridges. He pushed the demand for steel up, which provided him with even greater returns.

DID YOU KNOW?
John D. Rockefeller, the American oil tycoon, is often thought to have been the richest person in American history, with a net worth equivalent to around $340 billion today. However, Andrew Carnegie beat that, with a net worth equivalent to around $370 billion. Although he lived most of his life in America and built his wealth there, it seems he is frequently not included in the American 'rich list' due to not being born in America.

As his knowledge of the steel industry grew, he began to look at alternative methods for increasing its production. One such method, known as the Bessemer process, had first been conceived as early as 1847 and was developed both by Sir Henry Bessemer from England and William Kelly from the USA. It was not until 1856, however, that Sir Bessemer perfected the method and obtained a patent for the process. The furnace used was later redesigned by a Swedish expert in metal production, Goran Goransson, and the result was a way to mass produce steel at low cost. In Britain this steel was used largely to replace iron in the railway networks with steel, and in 1868, Andrew Carnegie introduced the method to America and revolutionised the steel industry there. By 1900, thanks to his investments and work in the steel industry, Carnegie had become one of the wealthiest men in the world. In 1901, at the age of sixty-five, he decided to retire and sold his shares in the steel-making industry, which earned him over $200 million to add to his already vast fortune.

Having always believed in supporting good causes to encourage people to make the most of their lives, he spent his retirement years donating money to good causes. He returned to Scotland every year and purchased Skibo Castle

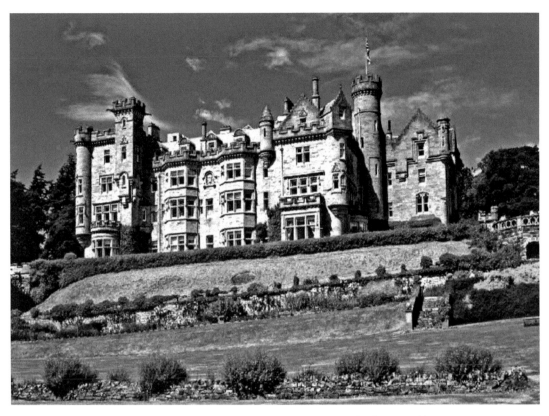

Skibo Castle near Dornoch in 1983. (© Christine Matthews (cc-by-sa 2.0))

in the highlands as a base. He donated around $5 million to the New York Public Library to allow it to expand and open new branches, and in 1904 he established the Carnegie Institute of Technology in Pittsburgh, now known as the Carnegie-Mellon University. In 1910 he formed the Carnegie Endowment for International Peace, and made multiple other donations. By the time he died in 1919, it is estimated that Andrew Carnegie had donated around $350 million, the equivalent of over $75 billion today, to causes he believed in, and it is estimated that there are more than 2,800 libraries worldwide that bear his name thanks to his donations.

In Dunfermline Andrew Carnegie gave endowments to establish the first public library in the town and public swimming baths. He also created the Carnegie Dunfermline Trust in 1903, which aimed to add value to the lives of the people of Dunfermline. As part of that trust he gifted Pittencrieff Park to the trustees for the future enjoyment of the people of the town.

The elaborate doocot in Pittencrieff Park.

Carnegie House on the outskirts of Pittencrieff Park.

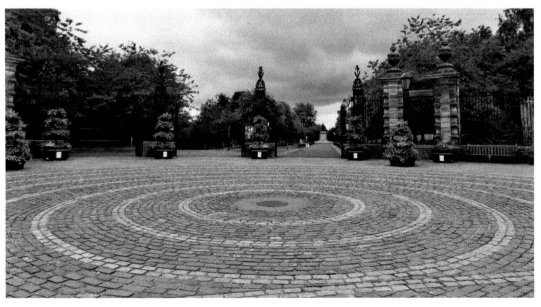

The entrance to Pittencrieff Park through the Louise Carnegie Gates.

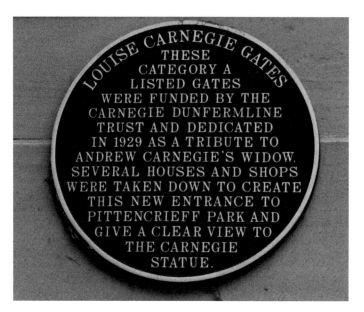

LOUISE CARNEGIE GATES
THESE
CATEGORY A
LISTED GATES
WERE FUNDED BY THE
CARNEGIE DUNFERMLINE
TRUST AND DEDICATED
IN 1929 AS A TRIBUTE TO
ANDREW CARNEGIE'S WIDOW.
SEVERAL HOUSES AND SHOPS
WERE TAKEN DOWN TO CREATE
THIS NEW ENTRANCE TO
PITTENCRIEFF PARK AND
GIVE A CLEAR VIEW TO
THE CARNEGIE
STATUE.

The plaque at the Louise Carnegie Gates.

The detailed metalwork of the Louise Carnegie Gates.

The legacy of Andrew Carnegie does, however, have a darker side, in what became known as the Homestead Strike of 1892. Carnegie Steel owned a steelworks in Homestead, close to Pittsburgh. The highly skilled workers were members of a union named the Amalgamated Association of Iron and Steel Workers, who had been able to negotiate a good salary and working conditions for its members. At the start of 1892 the mill made profits in excess of $4 million, which Carnegie saw as great business success. However, the chairman of the mill wanted more and complained that the restrictions placed on the business by the union stopped the mill from producing the levels of steel it was capable of. Matters were further antagonised when a local historian wrote that the workers at Homestead were the highest paid in the country. With a three-year deal with the union on wages due to come to an end later in 1892, the mill owners made their position clear: the workers were all to take a wage cut, and there was to be no negotiation.

DID YOU KNOW?

As well as being a steel magnate, Andrew Carnegie published a number of books. His 1886 work titled *Triumphant Democracy* looked at the American republic system of government compared to the British system, and concluded that the American system was significantly superior. Needless to say, it was not popular in Britain, yet sold over 40,000 copies in the United States of America, a high number for the time.

Needless to say the unions rejected the offer and the workers were enraged. The response from Henry Clay Frick, the operations manager that Carnegie had left in charge of the mill with instructions to deal with the union, was he had a tall, barbed wire fence constructed around the mill, and the workers were locked out. On 2 July 1892, Flick sacked all 3,800 workers, and under the darkness of night he brought around 300 Pinkerton Agents, who were skilled private security guards, by barge to occupy and protect the premises. Fearful that this was the first steps towards replacing the workforce, the employees stormed the building and the pier on which the Pinkerton Agents were landing, resulting in a bloody battle. Gunfire rang out for around twelve hours, before the Pinkertons surrendered and the workers took occupancy in the mill. At least three Pinkertons and seven workers were killed, and many more were injured. Frick responded by asking the Governor of Pennsylvania for help, and around 8,500 members of the National

Guard were sent in to force the workers from the building. By July 15 1892 the mill was once again operational with non-union associated workers. The fight with the union continued, but the striking workforce had little public support due to their attack on the Pinkertons, and eventually at the end of 1892 the union gave up. Many of the workers reapplied for their jobs, returning on reduced salaries with longer working days.

The results of the strike, which was in fact more a case of the workforce being locked out and replaced, was effectively the end of the unions in the steel industry of the time. Given that Carnegie had, as a young boy, witnessed his own uncle being arrested for striking, the harshness of the action seems out of character. However, it should be remembered that he was in fact out of the country at the time, leaving Henry Frick to deal with the situation. Whether Carnegie approved of the methods will never be known, yet many do still blame him for the destruction. In his home town, though, Andrew Carnegie will always be remembered as the local lad who became one of the richest men in the world, only to give most of it away again to help others.

The Carnegie Public Library.

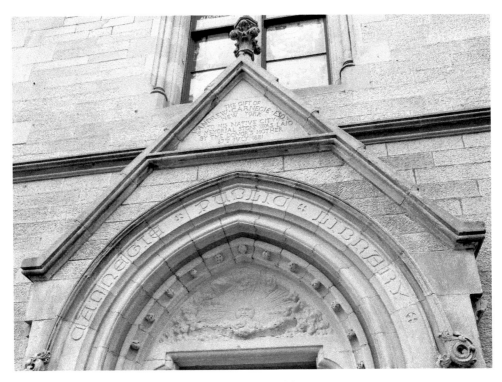

The commemoration above the door to the public library.

The Carnegie Conference Centre next to Fife College.

The Carnegie Hall.

The Louise Carnegie Bandstand was manufactured in Glasgow in 1888 and given to the people of Dunfermline as a thank you gift from Louise Carnegie in 1888. (© Thomas Nugent (cc-by-sa 2.0))

Dunfermline Today

After the world wars, the traditional industries in Dunfermline started to close due to fierce competition and the ever-changing lifestyle people were leading. Over the decades, it did reinvent itself once again, attracting electronic companies and other industries to the newly established business parks. The naval base remained in operation, although its operations were privatised. The dockyard became the sole location for refitting the Royal Navy nuclear submarines until the contract was moved elsewhere, and the yard has been involved in the decommissioning of nuclear submarines.

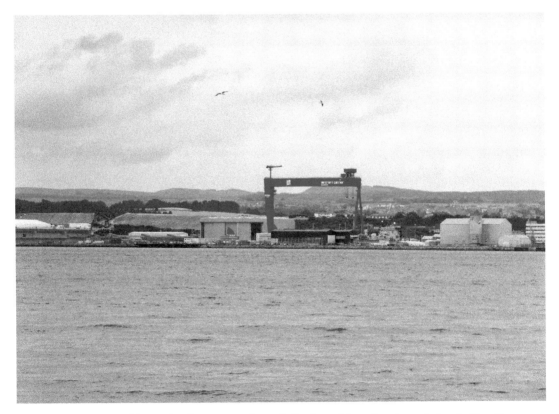

The distinctive blue Goliath Crane at Rosyth Dockyard has dominated the skyline for a number of years. It was brought in to build the Royal Navy's new aircraft carriers, HMS *Queen Elizabeth* and HMS *Prince of Wales*.

The entrance to the Amazon complex. (© Edward Mcmaihin (cc-by-sa 2.0))

The Andrew Carnegie Birthplace Museum is one of the top tourist destinations in Dunfermline.

While there is no denying that Dunfermline has become a commuter town to a certain degree, thanks to the easy transport links to Edinburgh, it does also have significant employment within the town. In addition to the naval base, Amazon moved to the town a number of years ago to open a sizeable distribution centre on the outskirts of the town, and Dunfermline is considered to be a major service centre. The town also now benefits considerably from the tourist industry, with its historic buildings and the stories they have to tell attracting tens of thousands of people. With plenty of the open green amenity space for recreational purposes, there is no doubt that Dunfermline will continue to grow.

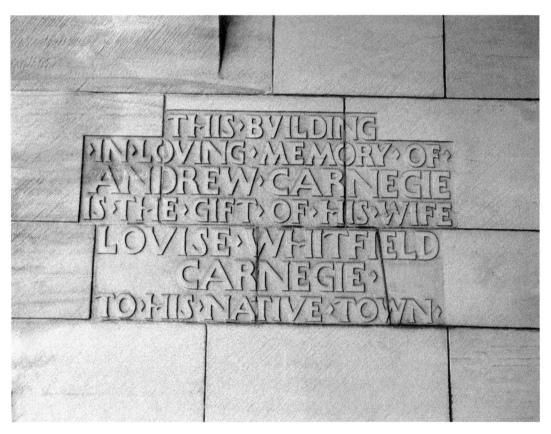

A dedication from Andrew Carnegie's wife at the Carnegie Birthplace Museum.

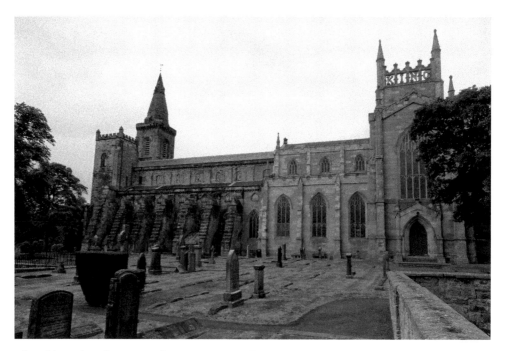

The abbey church is very distinctive in style, as it is literally two churches combined, with the newer section built onto the old. The old church and palace are looked after by Historic Environment Scotland as a tourist attraction.

Outside the Carnegie Library sit two statues depicting the famous Robert Burns characters Tam O'Shanter and Souter Johnnie. Known as 'The Men of Saline', these statues were carved around 1823 by Robert Forrest.

To the rear of Abbot House, a unicorn sits on top of a pillar. This incorporates shaft fragments from the former market cross, believed to be from the seventeenth century.

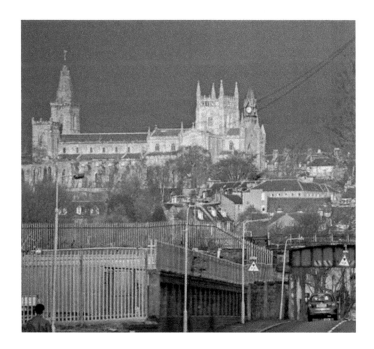

Dunfermline Abbey continues to dominate the skyline of modern Dunfermline. (© Paul McIlroy (cc-by-sa 2.0))

HMS *Queen Elizabeth*, the largest warship built for the Royal Navy, in the River Forth having left Dunfermline Docks. (© M. J. Richardson (cc-by-sa 2.0))

Bibliography

Books and Publications

Chalmers, Revd Peter, *Historical and Statistical Account of Dunfermline* (Edinburgh: William Blackwood & Sons, 1844)

Fordun, John Of, Fordun's Chronicle of the Scottish Nation, Translated by W. F. Skeene (Edinburgh: Edmonston and Douglas, 1872)

Goodare, Julian, *The Scottish Witch-Hunt in Context*, Manchester University Press, 2002

MacDonald, Stuart, *The Witches of Fife: Witch-Hunting in a Scottish Shire, 1560-1710* (East Lothian: Tuckwell Press, 2002)

Mercer, A, *Dunfermline from the Earliest Records down to the Present Time* (John Miller, 1828)

Scott, Hew, *The Succession of Ministers in the Church of Scotland from the Reformation* (Edinburgh: Oliver and Boyd, 1925)

Westwood, Alexander, *Westwood's parochial directory for the counties of Fife and Kinross, etc.* (A. Westwood, 1862)

Websites

BBC: https://www.bbc.co.uk/news/

Canmore: https://canmore.org.uk/

Dunfermline Abbey: https://dunfermlineabbey.com/wwp/?page_id=1183

Dunfermline Golf Club: http://www.dunfermlinegolfclub.com/Home.aspx

Dunfermline Historical Society: https://dunfermlinehistsoc.org.uk/

Electric Scotland: http://www.electricscotland.com/index.html

Historic Environment Scotland: https://www.historicenvironment.scot/

National Library of Scotland: http://www.nls.uk/

Reformation History: http://reformationhistory.org/presbyterianism.html

Royal Dunfermline: http://www.royaldunfermline.com/

The Andrew Carnegie Birthplace Museum: https://www.carnegiebirthplace.com/

The Fife Post: http://www.thefifepost.com/history/witches/

The Reformation: https://www.thereformation.info/

The Statistical Accounts of Scotland: http://stataccscot.edina.ac.uk/static/statacc/dist/home

Undiscovered Scotland: https://www.undiscoveredscotland.co.uk/index.html

Visit Dunfermline: https://www.visitdunfermline.com/culture-and-heritage/

About the Author

Gregor was born and raised in the town of St Andrews in Fife. Having been surrounded with history from a young age, his desire to learn about the past was spiked through his grandfather, a master of gold leaf work, whose expertise saw him working on some of the most prestigious buildings in the country, including Falkland Palace. After talking to other staff in these monuments, he would come back and recall the stories to Gregor, normally with a ghost tale thrown in for good measure.

Growing up, Gregor would read as many books as he could get his hands on about ghost lore, and going into adulthood, his interest continued and he would visit many of the historic locations he had read about. After taking up paranormal investigation as a hobby, Gregor started to become frustrated at the lack of information available behind the reputed hauntings. He has always felt it is easy to tell a ghost story, but that it is not so easy to go back into history to uncover exactly what happened, when and who were the people involved, that might lead to an alleged haunting. He made it a personal goal to research tales, by searching the historical records to try to find the earliest possible accounts of both what had happened, and the first telling of the ghost story, before it was adjusted as it was handed down from generation to generation. This proved to be an interesting area to research, and Gregor found himself with a lot of material and new theories about what causes a site to be allegedly haunted. After having several successful books published about the paranormal, Gregor found himself uncovering numerous forgotten or hidden tales from history. These were not ghost related, but were stories too good to remain lost in the archives, and he looked to bring the stories for specific towns together to tell the lesser-known history, often including the darker side.

Gregor's first book in this area was *Secret St Andrews*, telling the long and often brutal history from his own neighbourhood. He has since gone on to write two further books on St Andrews, and one about Dundee. Prior to turning his attention to Dunfermline he completed *Secret Inverness*, and is scheduled to write both *Secret Dundee* and *Secret Stirling*.

Also available from Amberley Publishing

·SECRET·
INVERNESS

GREGOR STEWART

Explore the secret history of Inverness through a fascinating selection of
stories, facts and photographs.
978 1 4456 7833 7
Available to order direct 01453 847 800
www.amberley-books.com

Also available from Amberley Publishing

Explore the secret history of Dundee through a fascinating selection of
stories, facts and photographs.
978 1 4456 7843 6
Available to order direct 01453 847 800
www.amberley-books.com